IMAGES
of America

A LEGAL HISTORY OF MARICOPA COUNTY

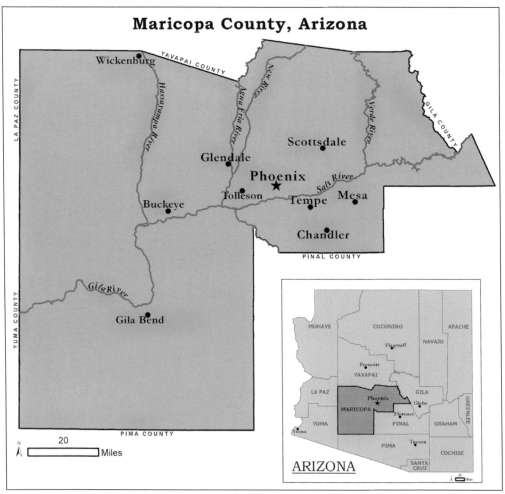

This map of Arizona shows the location of Maricopa County. It highlights the county's major communities and the desert rivers that made the Salt River Valley's growth possible. Phoenix is both the county seat and the state capital. (Jacob Watts.)

ON THE COVER: The epicenter of the county's legal history is the Maricopa County Courthouse. Justice has been meted out in a uniquely Western style from this site, located between Washington and Jefferson Streets and First and Second Avenues in downtown Phoenix, for over 120 years. Built in 1884, the courthouse is pictured here in the late 1890s. (McL, CPMCL-96869.)

IMAGES
of America

A LEGAL HISTORY OF MARICOPA COUNTY

Stan Watts

ARCADIA
PUBLISHING

Copyright © 2007 by Stan Watts
ISBN 978-0-7385-4815-9

Published by Arcadia Publishing
Charleston SC, Chicago IL, Portsmouth NH, San Francisco CA

Printed in the United States of America

Library of Congress Catalog Card Number: 2007930683

For all general information contact Arcadia Publishing at:
Telephone 843-853-2070
Fax 843-853-0044
E-mail sales@arcadiapublishing.com
For customer service and orders:
Toll-Free 1-888-313-2665

Visit us on the Internet at www.arcadiapublishing.com

To Wesley, my reason for telling stories, and to Suzanne for inspiring me to discover them.

Contents

Acknowledgments		6
Introduction		7
1.	In the Beginning	9
2.	Impact Players	29
3.	The Halls of Justice	45
4.	Case History	67
5.	All Work and No Play	85
6.	Getting There Is Half the Fun	111
7.	Freedom of Association	121

ACKNOWLEDGMENTS

This project could not have been possible without the help and inspiration of a great many people and institutions; it is impossible to thank everyone who had a part. Special thanks are due to Dr. Jack August and his exceptional staff at the Arizona Historical Foundation, specifically Jared Jackson, Elizabeth Scott, and Erica Johnson; Robert Spindler and his staff in the Archives and Special Collections Department of the Arizona State University Libraries; and the many other archivists throughout Arizona who were generous with their time and advice. Also deserving special mention are the Maricopa County Bar Association and the editorial board of the *Maricopa Lawyer*, whose support and cooperation have encouraged this effort. Thanks finally to my law partner, Suzanne Dohrer, for her willingness to shoulder more than her share of the burden of our practice while this project was in the works; and to Burline, Josh, Kris, Zach, Meghan, Jake, and Amy, whose support never wavered.

Photograph Credits:
AA—Arizona State Library, Archives and Public Records, Archives Division
AHF—Arizona Historical Foundation
ASU—Arizona State University Libraries
LoC—Library of Congress, Washington, D.C.
Lu—Luhrs Family Photographs, Arizona Collection, Arizona State University Libraries
Ly—Jack Lynch Photographs, Arizona Collection, Arizona State University Libraries
McC—McCulloch Brothers Photographs, Herb and Dorothy McLaughlin Collection, Arizona State University Libraries
McL—Herb and Dorothy McLaughlin Photograph Collection, Arizona Collection, Arizona State University Libraries
MCSC—Maricopa County Superior Courts
PMH—Phoenix Museum of History
PPL—McClintock Collection, Arizona Room, Phoenix Public Library
RR—Ryder Ridgway Photographs, Arizona Collection, Arizona State University Libraries
UAP—University Archives Photographs, Arizona State University Libraries

INTRODUCTION

A legal history is necessarily a history of people, places, events, and intangible ideas and concepts. Notions of justice and civil rights intermingle with famous and notorious men and women in the context of courtrooms, law offices, trials, and executions. The law is a cloak that covers virtually every aspect of community life and takes on the nature of that community. The legal history of Maricopa County has been shaped by the character of the region and has also been an important factor in shaping that character.

From the earliest days of pioneer settlement, Maricopa County's legal professionals both led and reflected the communities they served. Lawyers and judges who owned some of the first farms battled to secure long-term stable water supplies for the agricultural economy. Future lawyers and judges were subjected to the segregation and prejudice that they would eventually confront in court and as political leaders. Lawyers and judges were property owners, entrepreneurs, and politicians who helped promote the growth and prosperity of a huge, rapidly expanding metropolis. Lawyers and judges were the sports fans, the outdoorsmen, and the arts patrons who helped create a community rich in culture, with diverse professional and collegiate sports teams, and an appreciation of the natural beauty of Arizona.

The roots of the county's legal history lie in the fertile soil of the Salt River Valley. River systems, essential for the agricultural dynamo of Maricopa County to develop, are also at the forefront of the area's legal history. Determining who owned the water, how it would be distributed, and whether the supply could be sustained to support the continued growth of the valley have been the foundational issues faced by the community. With a secure water supply, agriculture flourished, and the legal community developed commercial and financial expertise to support it. As growth followed, legal professionals and their neighbors dealt with issues of immigration, development, education, health care, law enforcement, changing social and professional norms, transportation, cultural diversity, and a threatened desert ecosystem.

Maricopa County has a heritage of pioneer spirit, particularly in the area of law. From its ranks came important trailblazers like the first female chief justice of any state supreme court, Lorna Lockwood; the first Hispanic federal district court judge, Valdamar Cordova; the first Chinese American federal judge, Thomas Tang; the first Asian American elected to state office, Wing Ong; and the first female justice of the U.S. Supreme Court, Sandra Day O'Connor. Important cases handled by Maricopa County lawyers and courts have established fundamental immigration and civil rights law; the right to an attorney for suspects; Arizona's rights to Colorado River water; the equal rights of female retirees; and the rights of attorneys to advertise and practice law without regard to their political beliefs.

The legal history of Maricopa County is a history of the men and women who planted the seeds and tended the growth of what would become a thriving community in the "Valley of the Sun."

One

In the Beginning

In 1521, Hernan Cortez placed what is now Maricopa County, Arizona, under the dominion of Spanish law. Early in his conquest of New Spain, Cortez sought and received permission from the Spanish king Charles I to prohibit "attorneys and men learned in the law from setting foot in the country on the ground that experience had shown they would be sure by their evil practices to disturb the peace of the community."

Although Cortez's anti-lawyer edicts were eventually rescinded, it is unlikely that any Spanish lawyer ever ventured into the remote northern frontier that is modern Maricopa County. From 1821, when Mexico gained its independence from Spain, until the United States acquired the region north of the Gila in the Mexican War and it became part of the New Mexico Territory in 1850, the predominant legal policy was "let it be obeyed but not enforced."

After the United States obtained the remainder of Arizona via the Gadsen Purchase in 1854, years passed before the legendary lawlessness of the region was officially addressed. President Buchanan complained in his 1859 State of the Union Address that Arizona was "practically destitute of government, of laws, or of any regular administration of justice. Murder, rapine, and other crimes are committed with impunity." Although over the years the Maricopa County region was nominally within the jurisdiction of New Mexico territorial courts, the courts of an unauthorized provisional Arizona territorial government, and finally the courts of the Confederate Territory of Arizona, legal chaos prevailed.

In 1863, President Lincoln approved the creation of the Arizona Territory. Not until the late 1860s did the dust of the Salt River Valley settle onto the open pages of Arizona territorial law. Maricopa County was established by the territorial legislature on February 17, 1871, and a temporary courthouse was established in the first permanent structure built in Phoenix, a small adobe building near what would become Washington and First Streets.

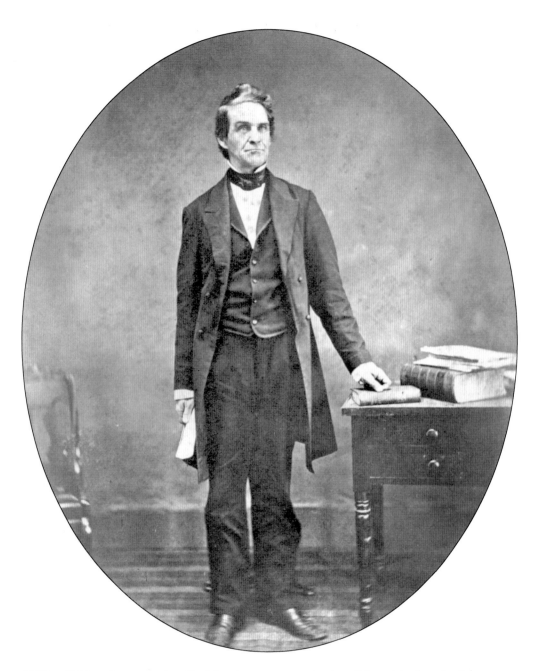

William T. Howell was appointed by Lincoln to serve as a justice of the original territorial supreme court and the first judge for the First Federal Judicial District Court in Tucson. Upon his arrival in Arizona in 1864, Howell was commissioned to draft a legal code for the territory. Based on New York, California, and Mexican/Spanish law, the Howell Code was adopted by the First Territorial Legislature. Judge Howell presided over Arizona's first civil lawsuit—a case involving the future founder of Phoenix, Jack Swilling, and the father of future senator Carl Hayden. Howell accepted a guilty plea in the territory's first criminal case and tried its first murder case on June 6, 1864. After this initial six-day court term, he returned to the East to be with his ailing wife and never returned. (AHF, N-538.)

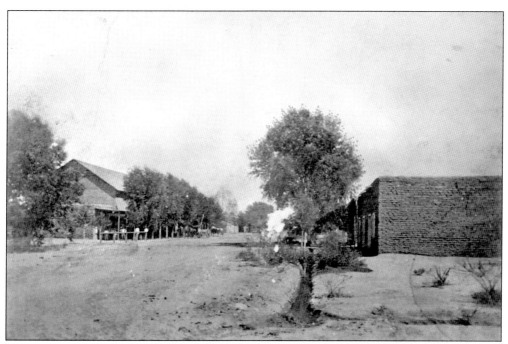

Phoenix was established as the seat of Maricopa County in early 1871. The town was founded through the efforts of the Salt River Town Association in 1870 and was eventually incorporated in 1881. With broad thoroughfares and cottonwood-lined streets, it billed itself as the "Garden Spot of the Arizona Territory." This is an early view of Washington, the main street. (AA, #97-0001.)

By the late 1870s, Phoenix was home to 10 or more stores, 3 flour mills, and a good public school with both primary and intermediate classes. Its public library had at least 250 volumes. The metropolitan-area population totaled 1,500. Jim Cotton's Saloon, shown here, was a popular hangout for lawyers and politicians because of its proximity to the courthouse. (AHF, FPMC-H-283.)

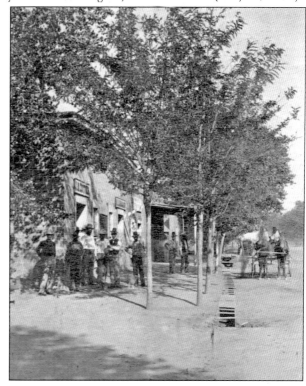

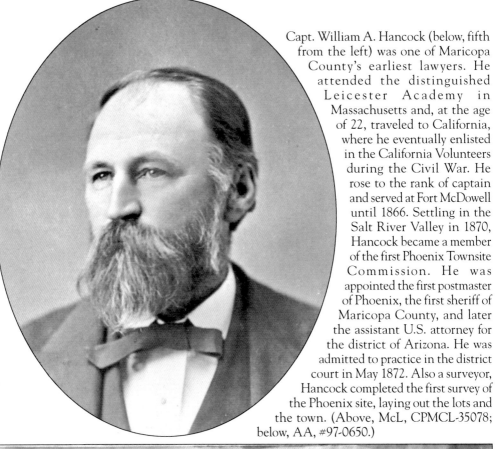

Capt. William A. Hancock (below, fifth from the left) was one of Maricopa County's earliest lawyers. He attended the distinguished Leicester Academy in Massachusetts and, at the age of 22, traveled to California, where he eventually enlisted in the California Volunteers during the Civil War. He rose to the rank of captain and served at Fort McDowell until 1866. Settling in the Salt River Valley in 1870, Hancock became a member of the first Phoenix Townsite Commission. He was appointed the first postmaster of Phoenix, the first sheriff of Maricopa County, and later the assistant U.S. attorney for the district of Arizona. He was admitted to practice in the district court in May 1872. Also a surveyor, Hancock completed the first survey of the Phoenix site, laying out the lots and the town. (Above, McL, CPMCL-35078; below, AA, #97-0650.)

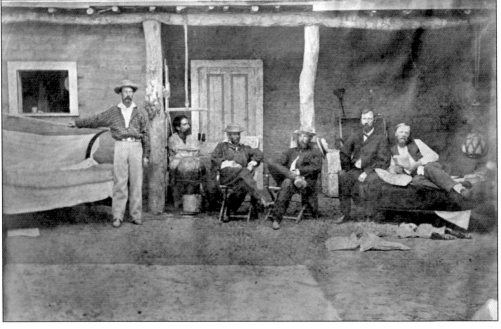

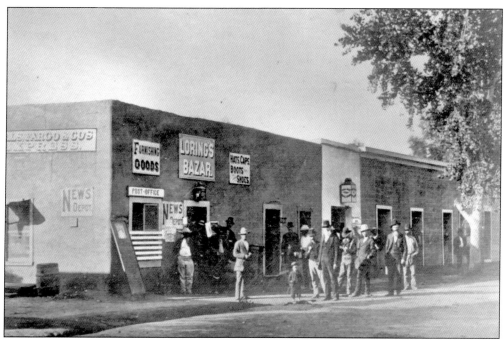

In January 1871, near the southwest corner of what is now Washington and First Streets, Captain Hancock built the first permanent structure in the vicinity, a small adobe store and butcher shop that also housed the first county officers and served as a temporary courthouse. This late-1870s image features the third building constructed in Phoenix, just a few doors down from the original location of Hancock's store. (McL, CPMCL-35075.)

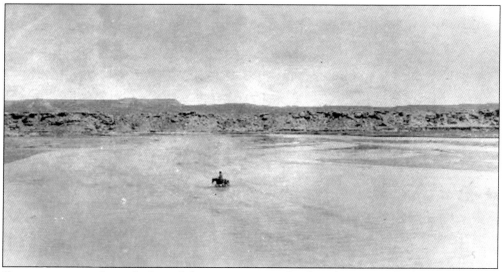

Court sessions in the early days of the county required judges, lawyers, and other personnel to travel hundreds of miles on horseback. Before the railroad and stagecoach routes were established, legal professionals faced attacks by bandits and hostile Native Americans and long, dusty days on the trail to reach the remote courtroom in Phoenix. Here a lonely rider fords one of Arizona's rivers. (PPL, 7083R.)

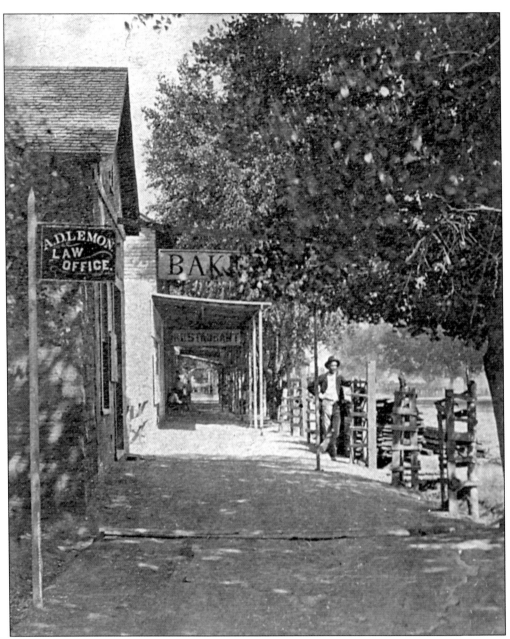

Attorney A. D. Lemon hung out his shingle in Phoenix in the 1870s. His law office was located at Center Street and Washington. Lemon and his family, including his wife, Eliza, and five children, were active in the community that by 1880 included 11 lawyers. Lemon served as a judge, a member of the territorial legislature, and as district attorney for several terms. He is most noted as the father of Arizona's public school system for his progressive, persistent, and eventually successful efforts in the legislature to secure public education for the children of the territory. Also a successful businessman, Lemon built what was Arizona's finest hotel of its day, later known as the Gold Hotel, due west of the courthouse. He and his family spent their summers in Salinas, California, and later moved to San Francisco. (AA, #97-7131.)

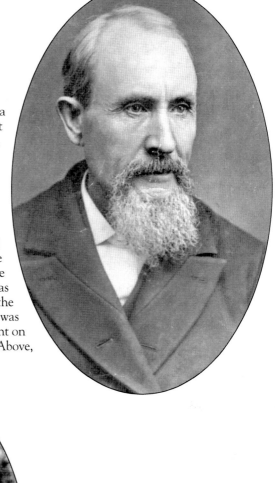

Dr. John T. Alsap, another of Maricopa County's original attorneys, is pictured at right. His second wife, Anna D. Murray, is seen below. After a short career as a prospector and military surgeon in the Apache campaigns of the 1860s, Dr. Alsap settled in the Salt River Valley in 1869, was elected to the territorial legislature in 1870, and aided in the creation of the new Maricopa County. In 1871, he was admitted to the bar and was appointed first probate judge of the county. He later served as the district attorney of Maricopa County and as Phoenix's first mayor. Acting as a trustee of the Salt River Valley Town Association, Alsap was granted the patent signed by President Grant on April 10, 1874, for the townsite of Phoenix. (Above, PMH, Alsap1; below, PMH, Alsap2.)

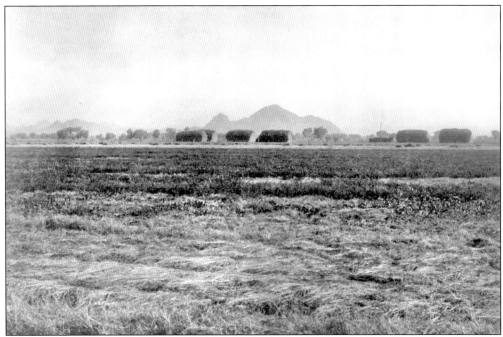

Building on the canal system originally constructed by the Hohokam people 1,000 years before, the first Maricopa County lawyers were drawn to the Salt River Valley to establish farms that would feed nearby military posts and booming mining towns. Early crops included barley, wheat, and sweet potatoes. Some farms produced excellent fruit orchards and vineyards. As early as the late 1860s, Salt River Valley farmers were experimenting with tobacco, peanuts, and pecans. Judge Alsap was one of these successful pioneer farmers, with 57 acres in production in 1870. Across the field above is a view of Camelback Mountain. Seen below is a typical early farm in the Mesa area. (Above, AHF, FPNA-2; below, McL, CPMCL-97194.)

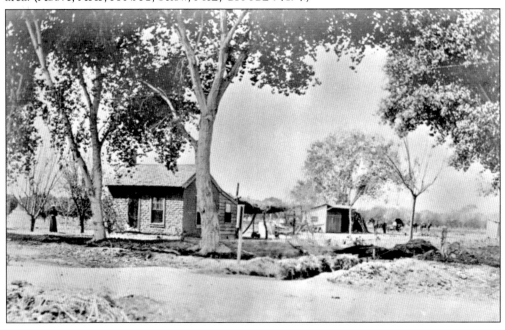

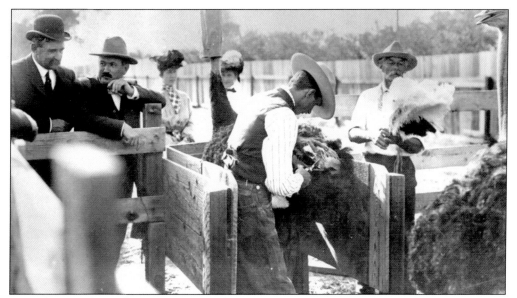

A single pair of ostriches was introduced in Maricopa County in 1891, and by 1906, Arizona was the leading domestic provider of ostrich feathers, with a herd of nearly 1,800 birds. The once-profitable business of supplying the fashion industry with feathers for hats, boas, and other accessories collapsed after World War I. Undoubtedly, at least a few local lawyers developed unique specialized skills in ostrich law. (AHF, FPCRE-286.)

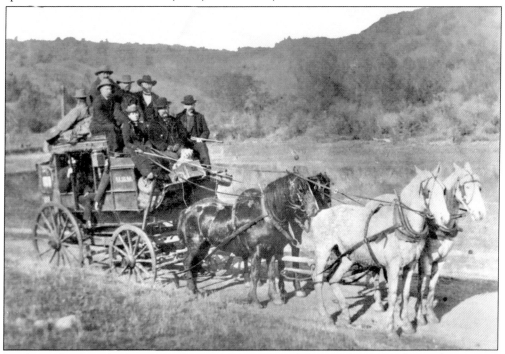

By the mid-1870s, the Yuma-to-Phoenix route, part of the Southern Pacific Mail Line, was operating high-quality Concord stagecoaches pulled by four- and six-horse teams. The big red coaches, sometimes carrying as many as 20 passengers, left on the 208-mile trip to Phoenix every other day. By 1878, daily service had been initiated. (AHF, FPXS-2.)

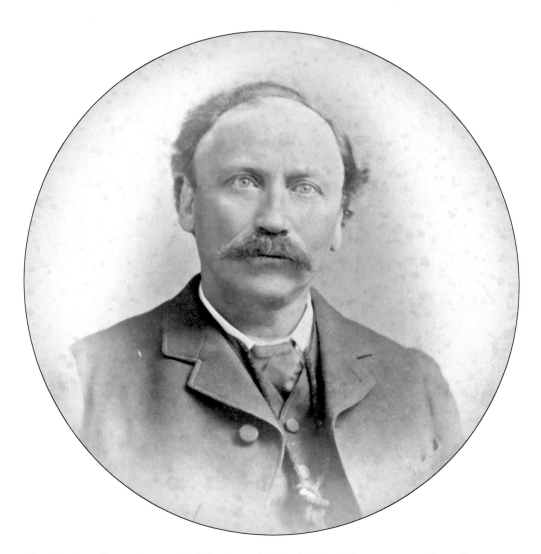

Hon. Deforest Porter (pictured) of the Second Federal Judicial District assumed jurisdiction over Maricopa County in 1878. From 1871 to 1878, the county had been part of the Third Judicial District under the authority of federal judge C. A. Tweed. According to the *Salt River Herald*, Judge Tweed was recognized as a "careful, upright and conscientious judge" who played a major role in making Phoenix a "warm place" for the "bullies and desperados" that had terrorized the community in its early years. With Judge Tweed, "punishment was so certain that they found it very unprofitable to continue their practices here." After his appointment, Judge Porter, a future mayor of Phoenix, married the daughter of saloon proprietor/developer Jim Cotten. Lulu Porter was instrumental in acquiring the land for establishing what would become part of the Pioneer Cemetery in Phoenix. Her father, who died in 1888, appears to have been the first person buried there. (AA, #97-7181.)

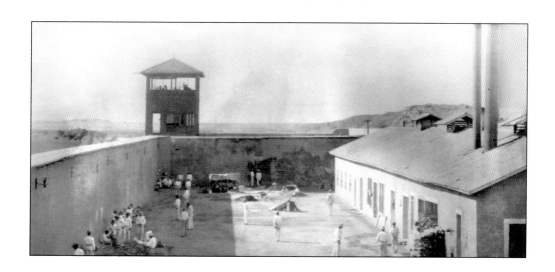

Those unfortunate enough to be arrested and convicted of serious crimes in early Maricopa County were likely to receive a sentence of hard labor at the notorious Yuma Territorial Prison. In operation from 1876 through 1909, the prison was built by its original seven prisoners. Over the years, more than 3,000 prisoners, including 29 women, were incarcerated here. Of these inmates, 111 died, including the colorful founder of Phoenix, Jack Swilling. After Swilling joked that he and a friend matched the descriptions of bandits accused of robbing a stage, he was swiftly arrested and transported to Yuma to be held pending investigation. No indictment was ever issued. Above, prisoners can be seen exercising in the yard. The prison rock pile shown below provided a purposeful existence for the criminal residents. (Above, RR, CPRR-768B; below, AA, #98-6973.)

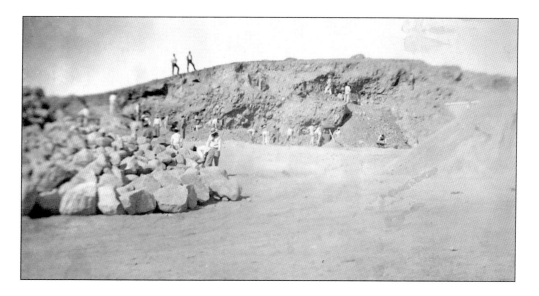

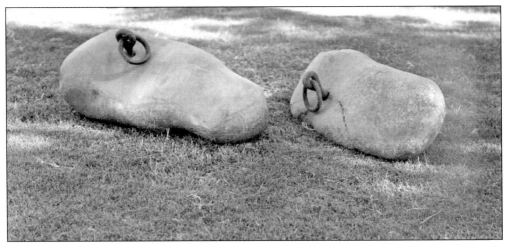

Before the county devoted scarce resources to the construction of a jail, prisoners in Phoenix were shackled to these boulders while awaiting disposition of their cases. Prisoners in Wickenburg were chained to the jail tree, an old mesquite, from 1863 to 1890. (AHF, FPMC-H-192.)

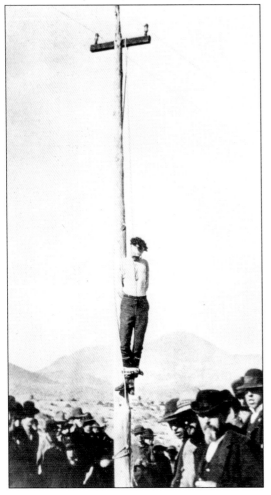

Despite the presence in Phoenix of a federal judge and a handful of distinguished lawyers, Maricopa County faced its first fatal instance of vigilante justice early on the morning of July 3, 1873. Mariano Tisnado had been arrested for stealing a farmer's milk cow, but was then found to be in possession of a ring belonging to a young man named Griffin who had been murdered and robbed en route to Tucson. Tisnado was subsequently hanged on a corral gate post. John Heath, shown here, faced a similar fate in Tombstone. (AHF, FPN-744.)

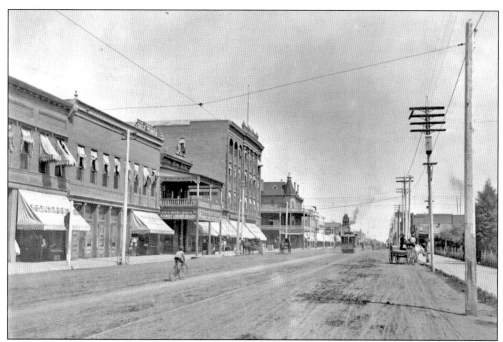

Phoenix grew steadily in the territorial years (above). With rail connections to Eastern and California markets and steady improvements to irrigation canals, the county prospered. The legal community grew from a small handful of lawyers in the early 1870s to a robust population of over 50 by the end of the territorial period. Most, if not all, were capable of handling the general legal needs of their clients, including civil and criminal matters. Several were experts in water rights, mining law, land grants, and agricultural issues important to the economic development of the county. Officials rewarded this growing area with the construction of the Territorial Insane Asylum (below) and eventually with the designation of territorial capital. (Above, AHF, FPCRE-78; below, AHF, FPCRE-235.)

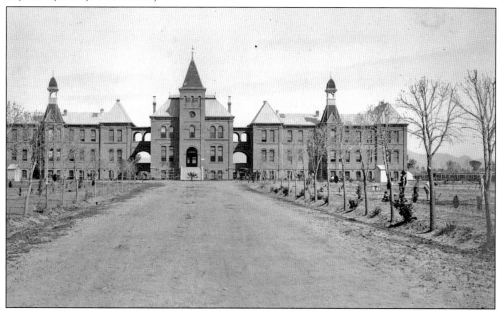

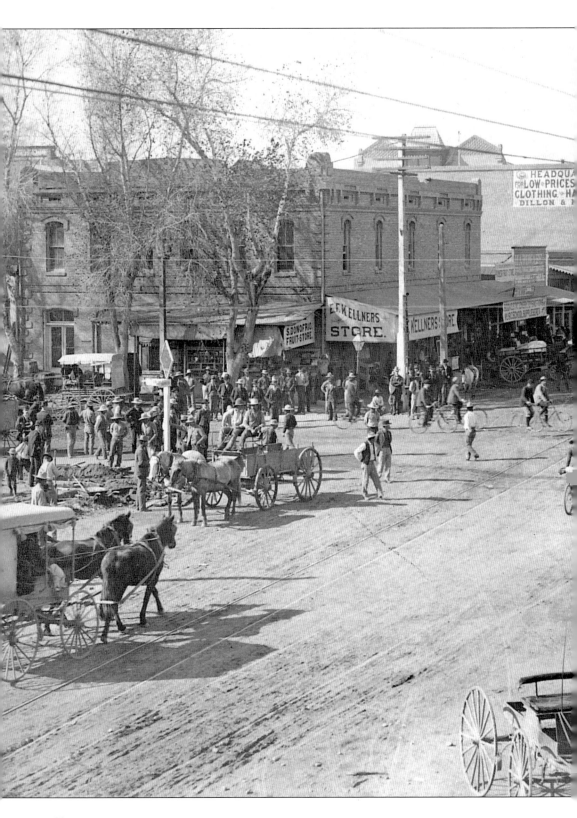

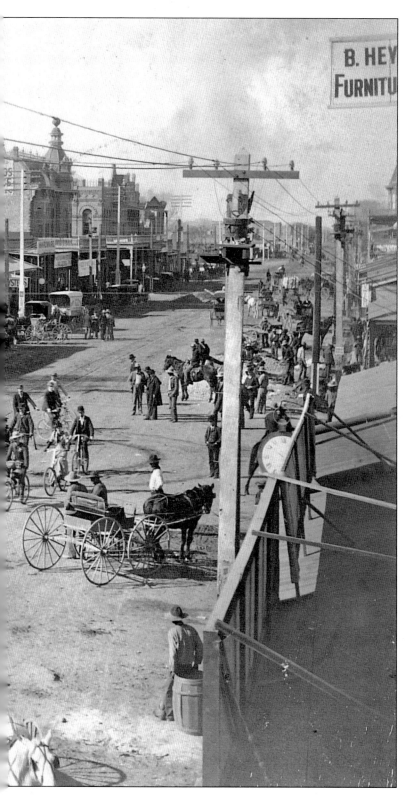

In the waning years of the 19th century, new modes of transportation sprang up. With pride, Phoenix's citizens, including its younger attorneys, adapted from their four-legged transportation to the two-wheel form. Bicycle parades, as shown here, added to the busy traffic of wagons, horses, pedestrians, and trolleys on Washington Street and were frequently seen from the courthouse plaza. The hustle and bustle reinforced the perception of a prosperous, thriving agricultural center. Note that both male and female bike riders joined the procession. All the men wore jackets and hats, and many wore vests to complete their biking attire. (AHF, Goldwater Historic Photographs.)

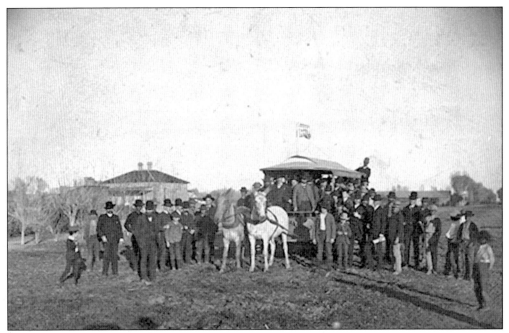

In 1887, the legal community welcomed the future with Phoenix's first streetcar. Here a group of local dignitaries celebrates the conclusion of the first run from Seventh Street to Seventh Avenue on Washington Street. For more than 50 years, the streetcar system would carry attorneys and others from their offices and homes to the county courthouse. (PMH, PMOH-0.)

The modern streetcar system also serviced Phoenix's grand city hall. Located in the midst of a beautiful park, complete with palm trees and a gazebo, the building occupied the heart of downtown between Central Avenue and First Street and Washington and Jefferson Streets. It was home to the territorial legislature prior to construction of the capitol. (AHF, FPCRE-3.)

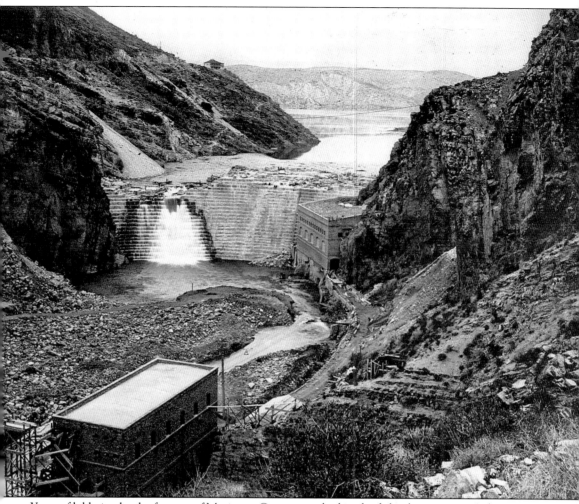

Years of lobbying by the farmers of Maricopa County resulted in the federal government's decision to build Roosevelt Dam in 1903. This decision, more than any other single factor, guaranteed the future prosperity of the Salt River Valley and its legal community. With a reliable source of water and power, the hostile desert was eventually tamed. Construction of the dam was one of the first projects of the new Bureau of Reclamation. John M. Rourke of Denver won the bid to construct the dam with a schedule of two years and a budget just over $1.1 million. As evidenced by this photograph, the construction of the dam was not uneventful. Severe flooding on several occasions delayed the project and resulted in massive cost overruns. Construction began in 1906, and the last stone was laid in 1911 on what was at the time the tallest masonry dam in the world. (AHF, FPDD-133.)

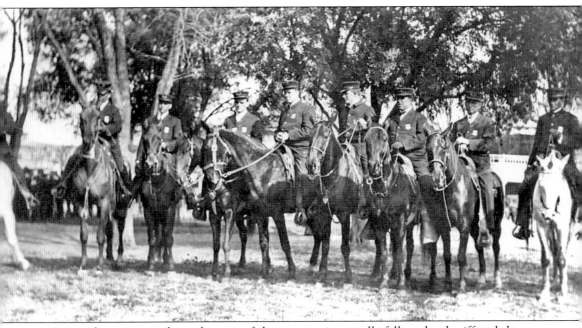

Law enforcement in the early years of the community usually fell to the sheriff and the town marshal. Enrique Garfias came to Phoenix in 1874 and became a deputy sheriff. In 1881, when the town was incorporated, Garfias entered a new role as the first town marshal, earning a reputation as a fearless and honest lawman. The *Phoenix Herald* reported that he "had the reputation of never going after a man that did not return with him, dead or alive." In 1902, the town's police department consisted of Chief McKinney and the legendary Andrew Jackson Johnny Moore. By 1906, Phoenix had a population of over 12,000, and Moore was chief of the fast-growing force pictured here. Moore was a renowned detective and respected lawman. Officers in the early 1900s patrolled by foot and on horseback. A motorcycle officer was added in 1911, and police cars were introduced prior to 1920. (AHF, FPCRE-9.)

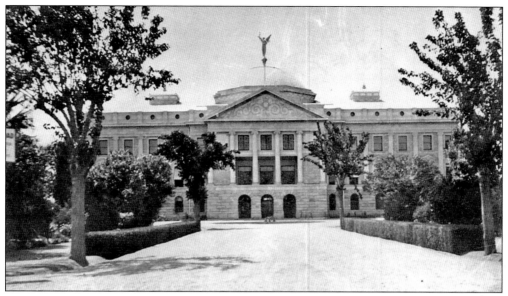

In 1904, the territorial capitol was completed in Phoenix, making Maricopa County the seat of governmental, agricultural, and economic development for the region. Local attorneys served with distinction in the legislative, executive, and judicial branches of government. This photograph provides a view of the new capitol and its surrounding grounds. (AHF, FPCRE-270.)

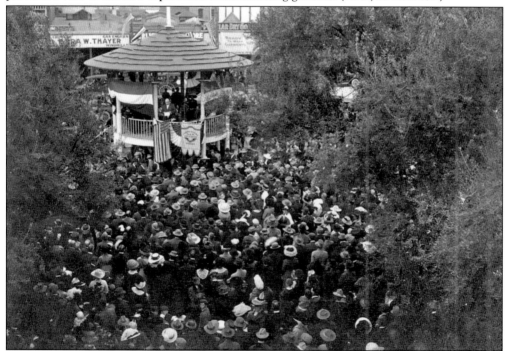

Arizona's territorial days came to a close on February 14, 1912. With much celebration, the citizens of Maricopa County jubilantly welcomed news that the reluctant Pres. William H. Taft had finally signed Arizona's statehood proclamation. William Jennings Bryan was in town to deliver a speech on that august occasion. Here Governor Hunt addresses the new state citizens in the crowded Phoenix City Hall Park. (AHF, FPCRE-6.)

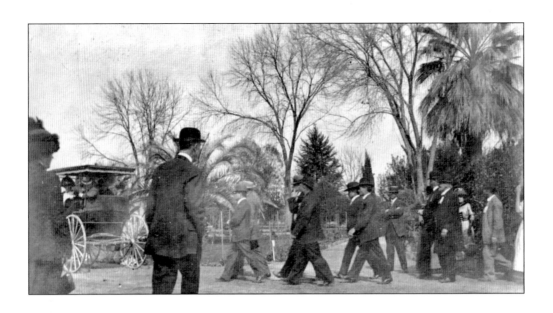

At the appointed hour, Governor Hunt led a procession of recently elected state officials and legislators west from the Ford Hotel, across from the county courthouse, to the capitol (above). When the crowd arrived, Hunt and others took their oaths of office to serve the newly minted state. Afterward, the statehood celebration continued with a huge parade on Washington Street (below). The reviewing stands in front of city hall were packed with the town's important residents and guests. No doubt, most members of the legal community were in their seats for the event. (Above, AA, #91-2117; below, McL, CPMCL-34952.)

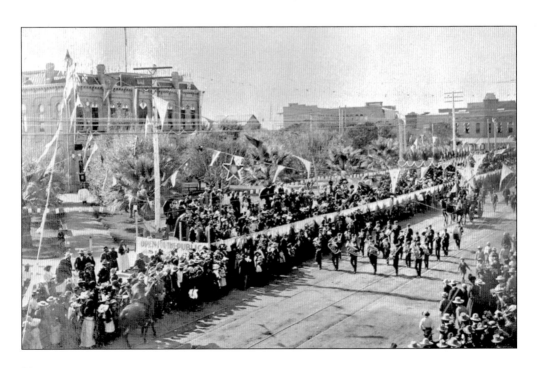

Two

IMPACT PLAYERS

At its core, the legal history of Maricopa County is a history of the colorful, talented, and influential men and women who served the community through the years as its lawyers and judges. The county has been fortunate from its founding to draw professionals of remarkable character and ability. Whether self-taught or graduates of Ivy League law schools, these attorneys played a major role in the evolution of the county from a sleepy, desert farming village to the nation's fourth most-populous county.

In the territorial and early years of statehood, lawyers were admitted to practice before the courts of Maricopa County if they were persons of "full age" and good moral character, United States citizens, Arizona residents, and officials licensed by the supreme court. Upon the recommendation of a local attorney and presentation of a certificate from the clerk of another court, already licensed attorneys were readily admitted to practice in Arizona courts. In the early days, before large numbers of attorneys made Maricopa County their home, it was not uncommon for a local lawyer to recommend admission of his nonresident opposing counsel in order for a trial to be held. During these early years, new lawyers were required to pass a written test (allegedly any applicant with little or no legal education could pass) and occasionally an oral examination, to submit letters of reference to establish moral character, and to pay the $10 application fee.

Under these rules, county lawyers were subject to little or no ethical oversight or disciplinary review until the state legislature approved the creation of an integrated bar (linking closely the supreme court and the new mandatory state bar association) on St. Patrick's Day in 1933. Lawyers became responsible for maintaining the professionalism of the bar, and heightened educational and ethical standards were soon promulgated for new members.

No partial list of Maricopa County lawyers can ever include all the attorneys who have made significant contributions to the community and legal system. The lawyers named here are among thousands who have litigated important issues, negotiated groundbreaking agreements, defended the poor, established the rights of minorities, and led their communities to confront the challenges of growth and change. Those mentioned have distinguished themselves in different ways and are representative of the many other unnamed barristers who impacted the region.

While having lunch at the Maricopa Wells stage stop after a deposition in Tucson in 1879, A. C. Baker was recruited to represent a Maricopa County client. Baker, an experienced San Francisco attorney, settled in the dusty frontier village of Phoenix and soon became one of the territory's most-respected attorneys. He went on to occupy both the territorial and state supreme court benches and chair the State Constitutional Convention. (AA, #97-6490.)

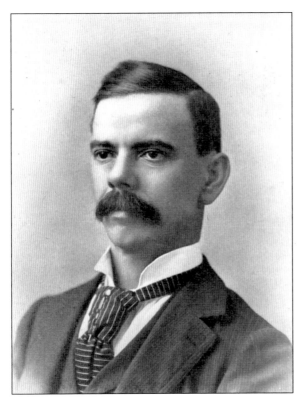

An Indiana lawyer before arriving in Arizona in 1888, Joseph Kibbey was appointed to the territorial supreme court and, in 1892, established the seminal Arizona water rights doctrine of prior appropriation in *Wormser v. Salt River Canal Company*. In 1902, he drafted the complex and controversial organizational documents for the Salt River Water Users Association. Two years later, President Roosevelt appointed Justice Kibbey as territorial governor. (AHF, Goldwater Historic Photographs.)

Judge Edward H. Kent, while sitting as a district judge in 1910, issued the Kent Decree for water users of the Salt River Valley, thereby establishing an equitable basis for allocating benefits and assessments related to the nearly complete Roosevelt Dam. Kent, a former New York attorney and son of the governor of Maine, was appointed chief justice of the territorial supreme court by his old Harvard chum Theodore Roosevelt in 1902. (AA, #97-7002.)

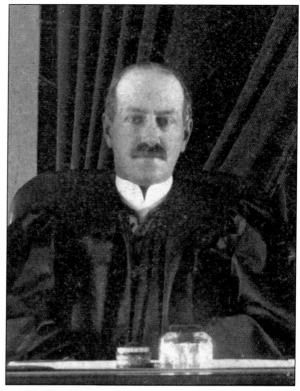

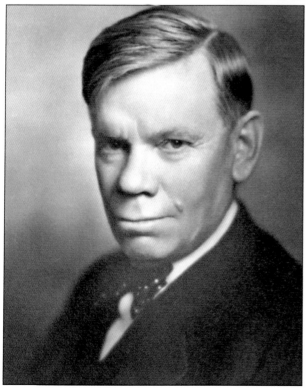

John Phillips was Maricopa County's first superior court judge and the only Republican to win a seat in the county election of 1911. "Honest John" refused to push for higher salaries for judges, explaining that "if we raise the salary, some really competent lawyer may run and beat me out of a job!" Phillips became Arizona's second Republican governor. An avid fisherman, he led the fight to establish the Department of Game and Fish and later died while fishing in Northern Arizona. (AA, #97-7925.)

Leon Jacobs was a hometown boy; born in Phoenix in 1886, he was the son of a prominent Jewish merchant. He was elected to the first Arizona House of Representatives in 1911 while still a law student. As chair of the House Code Revision Committee, he led the effort to codify the state's new laws and rules of procedure. Jacobs became a member of the Maricopa County Bar, practicing law into his 90s. (AA, #97-6645.)

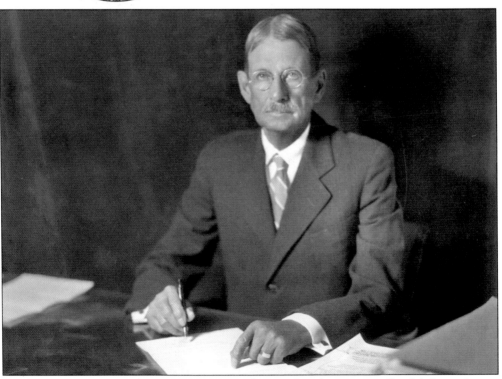

Frank Lyman, Maricopa's first county attorney after statehood, was originally a Michigan lawyer but hung out his shingle in Phoenix in 1893. Lyman's prestigious legal career spanned 66 years, including appointment to Division 2 of the Maricopa County Superior Court, two years on the supreme court, and a term as president of the Maricopa County Bar. (AA, #97-7689.)

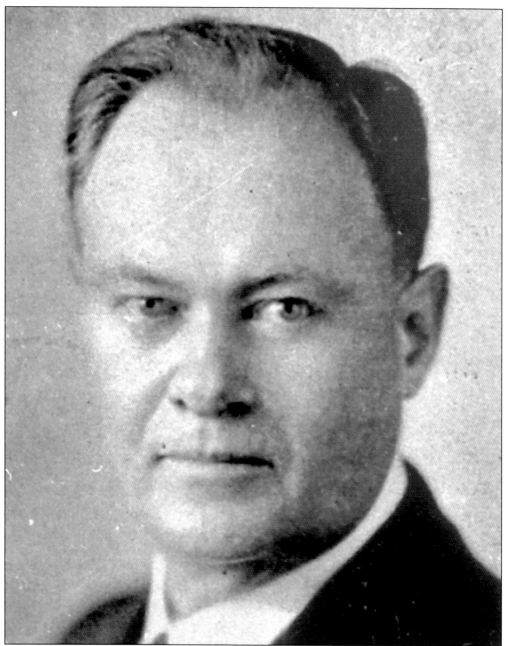

Rawleigh Stanford, pictured here, the Maricopa County Bar Association's first vice president in 1914, came to Phoenix as a child, attended Tempe Normal School for a year, and after a stint in the Spanish American War, studied law in Phoenix and Bisbee. After two years practicing in Tombstone, he returned to Phoenix. Stanford was elected judge of the superior court in 1915. He went on to become governor and to serve 12 years as justice of the Arizona Supreme Court. The founding president of the Maricopa County Bar Association was George Stoneman, the son of Gen. George Stoneman, who had been a major character in the Civil and Indian Wars and governor of California. Stoneman's uncle was a state senator from Iowa, and his aunt Kate was the first female attorney in New York. (AHF, FPBRN-275.)

WOMEN LAWYERS' JOURNAL

Entered as Second Class Matter Feb. 1, 1912, at the Post Office at Jamaica, N.Y., under the Act of March 3, 1879.

Vol. 2. No. 4. Published Quarterly JAMAICA, N. Y. City, FEB., 1913. 15 Cents a Copy; 50 Cents a Year.

Published by the
WOMEN LAWYERS' CLUB

TO WOMEN LAWYERS.

We extend a cordial invitation to all our Journal. You need us and we need you. For further information, write to the Chairman of the Membership Committee.

OLIVE STOTT GABRIEL,
77 Washington Pl., New York City.

NEWS ITEMS.

Proposed Children's Code of the State of New York.

Justice Joseph M. Deuel of the Court Of Special Sessions of the City of New York has drafted a code whose chief aims are establishment of children's courts throughout the whole State of New York, uniform procedure therein, and employment of scientific agencies for curative treatment.

The idea is commendable-to be so in the highest degree he should have included therein adequate recognition of the serious nature of the cases of delinquent girls and provision for a woman justice.

Miss Bartelme and the Juvenile Court.

Many inquiries have come to us regarding the exact nature of the position held by the Portia Club, in favor of the appointment of a woman as Associate Judge of the Children's Court in that city. A bill to this end is now being drafted for presentation to the Legislature of the State.

The College of Law of the University of California, located at Los Angeles, has had a large occasion of women students since California has become an equal suffrage State. There are now thirty women studying law and the subjects of Domestic Relations, Crimes and Torts, as to the women students, are taught by women attorneys.

With the endorsement of Dean Frank M. Porter and the aid of the Faculty the Phi Delta Delta Sorority has been established. The five original women charter members have secured a charter from the State and filed incorporation papers with the intention of making it a national affair -by establishing a bond of sisterhood among women law students all over the country.

The Washington College of Law has been invited to form the first chapter apart from the University of Southern California, and Dean Mussey and the Faculty have given their consent. The thirteen women members of the graduating class hope to organise their chapter within the next two weeks.

On Saturday, January 18, the Alumnae Association of the Woman's Law Class of New York University held its annual meeting College of Law on February 1st the guest of honor will be Miss Julia C. Lathrop, the Chief of the Child Bureau, who will speak on the work of her bureau.

Mrs. Georgie McIntire-Weaver, having been refused admission to the bar of Georgia, is preparing for admission in West Virginia, that she may then return and be admitted in her own State by the "Law of Comity."

Miss Litta Belle Hibben, one of the seniors of the Law Department of Southern California, will, according to Dean Porter, undoubtedly receive the medal for excellency in scholarship during the entire three years' course. She is a member of the Phi Delta Delta Sorority.

Miss Alice Birdsall, who graduated with high honors from the Washington College of Law last May passed the Arizona bar examination second and with her partner (another woman lawyer) constitute the only women practicing in that State.

Mrs. Clara Shortridge Foltz, of whom the legal profession is justly proud, sends her greetings to the East. We are glad to have her as a subscriber to the Woman Lawyers' Journal.

Speakers' Day at the Portia Club on Thursday, December 5, at the Hotel Astor, New York, was enjoyed by the Club and many guests. The President, Miss Mary M. Brenneman ably presided and intro-

In 1912, Alice Birdsall, at left, became the partner of Sarah Sorin, Arizona's first female lawyer, in Globe. Birdsall, in only one year of night classes, had completed a three-year study of law and achieved the highest marks ever awarded at Washington College of Law. Although two women from Maricopa County appear on the roll of the territorial supreme court in 1903, Vivian and Beatrice Hopson apparently did not stay long or have active practices. Birdsall was Maricopa County's only practicing female attorney when her offices opened in the Fleming Building in 1914. A Democrat, she ardently supported women's suffrage and vociferously advocated for the right of women to serve on juries. She served as official reporter for the Arizona Supreme Court from 1915 until 1934. Birdsall practiced in Phoenix until the late 1950s. (Above, Women's Legal History Biography Project, Robert Crown Law Library, Stanford Law School; below, McL, CPMCL-Port Birdsall, Ali-4.)

Greg Garcia Dies In His Law Office

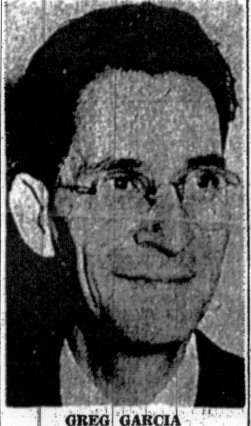

GREG GARCIA
Was Criminal Attorney

Greg Garcia, veteran Phoenix criminal attorney, died of a heart attack at noon today while discussing a court case with an associate.

Mr. Garcia, 60, was standing in his office on the fourth floor of the Goodrich Building when he swayed, cried "oh," and began to fall.

His law partner, V. A. Cordova, and the office secretary, Mrs. Ruth Zamora, caught him and lowered him to the floor. Cordova then ran to the floor below to summon Dr. Charles Kalil from the latter's office. Dr. Kalil went to the stricken man immediately and pronounced him dead.

MR. GARCIA HAD had a heart condition for about a year, and suffered an attack about nine months ago. He returned to his office last Friday after an absence of five weeks, during which he underwent an extensive examination in a Los Angeles hospital.

He was discussing his scheduled appearance in a criminal case in

After reading the law in St. Johns, Greg Garcia tried his first criminal case in Maricopa County in 1920. Garcia is believed to be the county's first Hispanic attorney. After starting his career as a court reporter, he was eventually recognized as a defender of civil rights and a noted criminal defense lawyer during his more than 30 years as a lawyer in Phoenix. Garcia became a member of the Maricopa County Bar Association and served as the supreme attorney for La Liga Protectora Latina, a popular mutual aid society established to help protect Mexican laborers from prevalent anti-immigrant backlash. Near the end of his career, in the early 1950s, Garcia partnered with another distinguished Hispanic civil rights lawyer, Ralph Estrada, to win *Gonzales v. Sheely*, thus ending the segregation of Spanish-speaking schoolchildren. (*Phoenix Gazette*, September 8, 1953. Used with permission. Permission does not imply endorsement.)

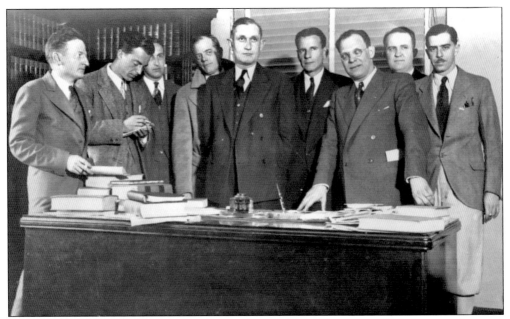

Oklahoma lawyer Howard C. Speakman started practicing in Phoenix in 1920. As a superior court judge, he presided over the "Trunk Murderess" trial of Winnie Ruth Judd, and in 1946, President Truman appointed him federal district court judge for Arizona. Here Judge Speakman (center) is shown with the gentlemen of the press covering the Judd trial. (Ly, CPSPC-57-52.)

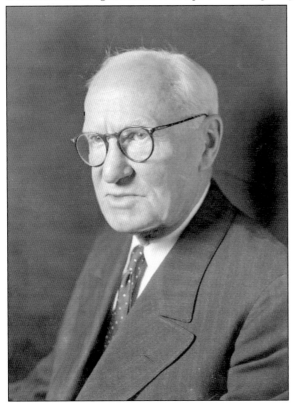

James R. Moore, a Maricopa County lawyer, served as president of the Arizona State Bar from 1932 to 1933 and was an important, successful advocate for the integrated bar (one that included all lawyers). He and other attorneys supporting mandatory bar association membership, with authority to enforce its rules of professional conduct, were viewed with suspicion by the legislature and many of their peers, but the proposed bill eventually passed and the modern state bar was created. (McL, CPMCL-Port Moore, James.)

Arizona's first Hispanic assistant attorney general, Albert Garcia, is pictured on a family outing to Nogales. Garcia graduated from the University of Arizona Law School in 1937 and became, along with his wife, Maria, a vocal advocate for the Hispanic community. After serving in World War II, Garcia opened his own law firm in Phoenix. (Frank Barrios.)

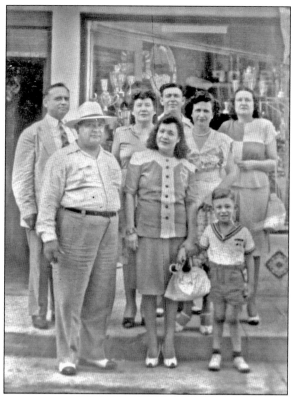

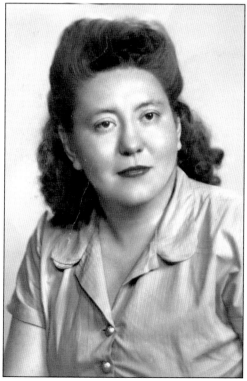

Anita Lewis is believed to have been Maricopa County's first Latina attorney and only the second female Hispanic lawyer in the country. In 1947, she began practicing in Phoenix, where she focused on family law and was a prominent leader in the fight against domestic violence. She opened her own home to women in need of shelter and used her legal skills and personal resources to help abused women start new lives. (Hon. Harriet Chavez.)

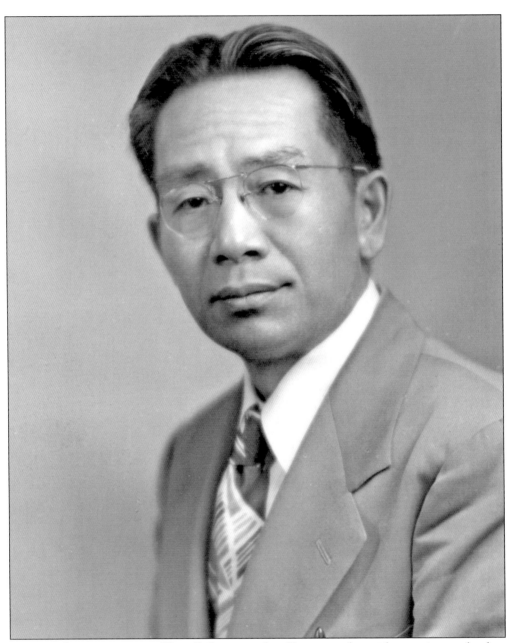

In 1918, Chinese immigrant Wing F. Ong moved to Phoenix in his mid-teens, in search of an opportunity to learn English. At the age of 15, he was permitted to enroll in elementary school. After working many jobs, including serving as a houseboy for Gov. Thomas Campbell, Ong owned a grocery and became the father of six children. Following an unsuccessful attempt for a seat in the Arizona State House of Representatives, he decided to become a lawyer. Leaving the store and children in the hands of his wife, Ong attended Phoenix College and graduated from the University of Arizona Law School in three and a half years. He opened his law offices in the back of his grocery and, in 1946, ran for the state legislature again. Successful, he became the first Chinese American to be elected to a state office. He practiced immigration law in San Francisco for a while and was later elected to the Arizona Senate. (AA, #98-0132.)

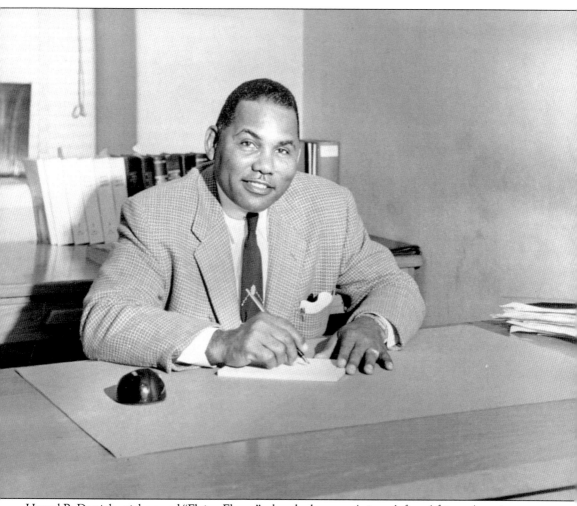

Hayzel B. Daniels, nicknamed "Flying Ebony" when he became Arizona's first African American All-State football player, received his law degree from the University of Arizona. In 1948, he passed the bar and moved to Phoenix to become Maricopa County's and Arizona's first African American attorney. Daniels was a strong and successful advocate for civil rights. Working with fellow civil rights attorney Herbert Finn and with the support of the NAACP, he succeeded in forcing the desegregation of Arizona's schools. His desegregation cases, including *Phillips v. Phoenix Union High School District* and *Heard v. Davis*, were considered by the U.S. Supreme Court in *Brown v. Board of Education*. Among other "firsts" by Daniels were his election as one of Arizona's first two African American legislators and his appointment as Arizona's first African American judge. (George Washington Carver Museum and Cultural Center.)

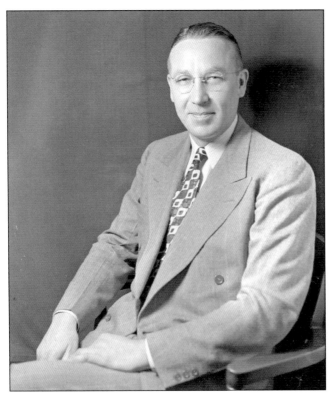

Mark Wilmer was often referred to as "The Dean" of Arizona's trial lawyers. His most-famous victory, in *Arizona v. California*, assured Arizona's access to the Colorado River and is widely considered the impetus for Arizona's tremendous growth. Wilmer is credited with shifting the focus in the long-standing water dispute from the doctrine of prior appropriation to an obscure statutory argument that eventually prevailed in the U. S. Supreme Court. (McL, CP MCLPORT Wilme, Mar.)

Charles Bernstein began practicing law in Phoenix in 1929. In 1946, he became Arizona's first Jewish judge. He served on the superior court for 10 years, during which time he rendered an important desegregation judgment in *Phillips*, which was considered by the U.S. Supreme Court. Bernstein, who was honored for his work in the juvenile court, later served as chief justice of the Arizona Supreme Court. (AHF, FPDD-85.)

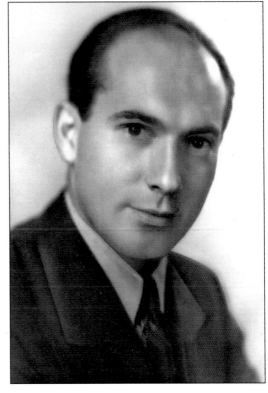

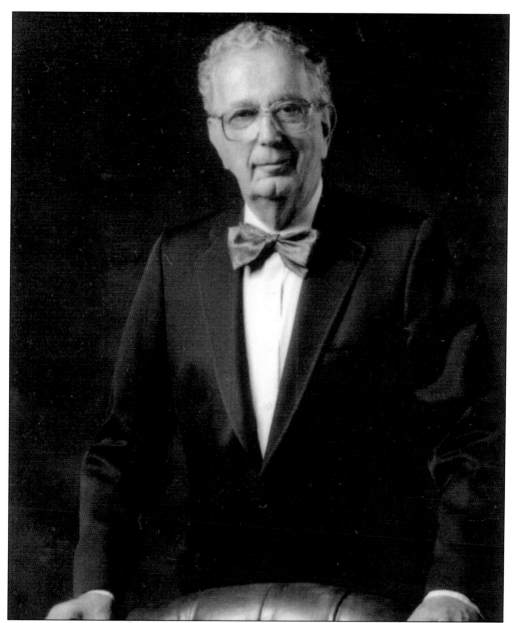

John Frank started practicing law in Phoenix in 1954. Prior to moving to Arizona for health reasons, Frank clerked for U.S. Supreme Court Justice Hugo Black and taught law at Indiana and Yale Universities. As a professor, he advised the NAACP, helping to strategize for success in *Brown v. Board of Education*. As an appellate attorney, he was involved in over 500 appeals, including the landmark cases of *Miranda v. Arizona*, in which the Supreme Court ruled that suspects must be advised of their right to legal counsel, and *Baird v. State Bar*, in which the high court declared that a state's power to inquire about a lawyer's beliefs or associations is limited by the First Amendment. Frank found time to lead the Federal Judicial Conference's Advisory Committee of Civil Procedure in its effort to revise Rule 11 of the Federal Rules, and to author 12 books on the Supreme Court, the Constitution, and constitutional law. (Estate of John Frank and Lewis and Roca, LLP.)

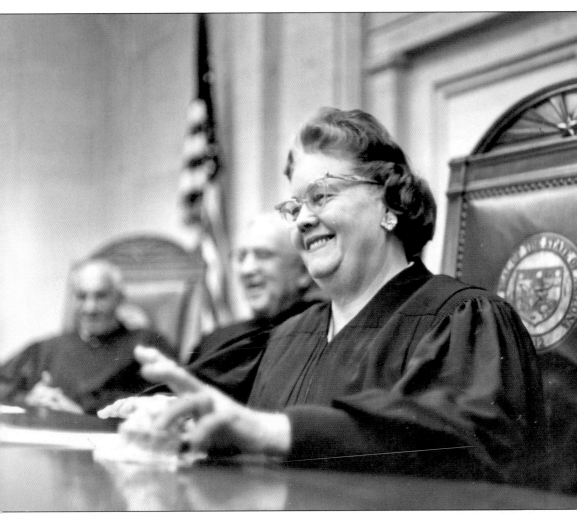

The only woman in her 13-member class at the University of Arizona Law School and the first woman to obtain a J.D. from that institution, Lorna Lockwood eventually became the first female justice of the Arizona Supreme Court and the first female chief justice of any supreme court in the country. After admission to the Arizona Bar in 1925, Lockwood, whose father was a justice of the Arizona Supreme Court, spent the next 14 years working as a legal stenographer. In 1939, she entered private practice with another female lawyer and was elected to the state legislature. In 1961, Lockwood became Arizona's first female judge as a member of the Maricopa County Superior Court. In 1967, she was seriously considered by President Johnson for nomination to the U.S. Supreme Court seat eventually held by Thurgood Marshall. (McL, CPMCL-91260-4.)

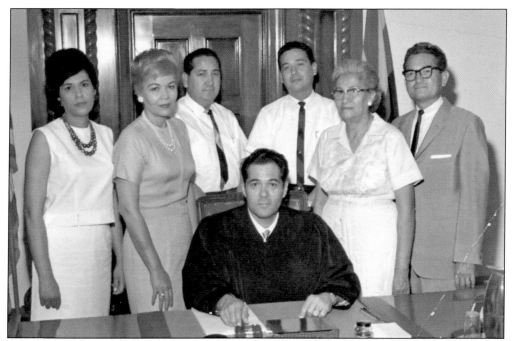

In 1979, Valdamar Cordova became the first Mexican American appointed to the federal bench. He grew up in a barrio near Grant Park in South Phoenix in the 1920s. He dropped out of high school to join the Army Air Corps during World War II but later obtained an undergraduate degree and graduated from the University of Arizona Law School as its student body president. He completed his degree in less than five years. Practicing in Phoenix, he served two terms as a Maricopa County Superior Court judge. (Candid Wedding Photographers and Yvonne Amador Photographs, ASU Libraries, MPSPC-221:2.)

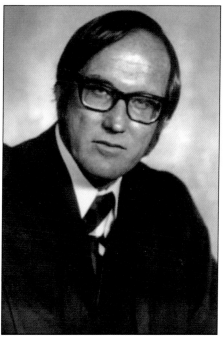

After graduating from Stanford Law School and clerking for U.S. Supreme Court Justice Robert H. Jackson, William Rehnquist practiced law in Phoenix from 1953 to 1969. During that time, he served as a legal advisor to Barry Goldwater's presidential campaign and participated in Republican politics. After a stint in the Nixon Justice Department, he was appointed to the U.S. Supreme Court in 1972 and served as chief justice from 1986 until his death in 2005. (LoC.)

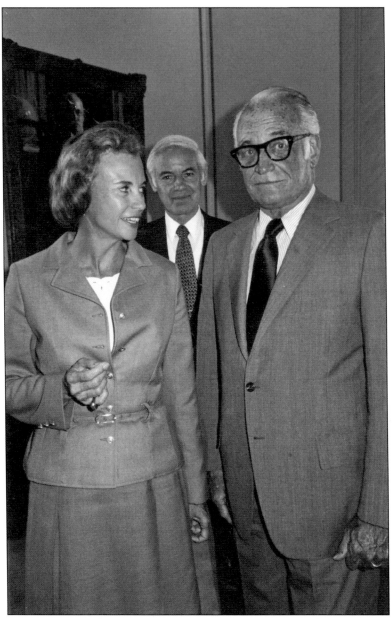

Sandra Day O'Connor, the daughter of an Arizona rancher, graduated third in her class of 102 from Stanford Law School in 1952 (the valedictorian was future chief justice William Rehnquist). After a stint as a government lawyer, she briefly opened a private practice in Maryvale, Arizona. She then went on to serve as a part-time assistant attorney general while her three sons were young. In 1969, she was appointed to the state senate, eventually becoming the first female majority leader. O'Connor was elected to the Maricopa County Superior Court bench in 1974 and was subsequently appointed to the Arizona Court of Appeals. In 1981, President Reagan nominated her to become the first female justice of the U.S. Supreme Court. Retiring in 2006, Justice O'Connor currently serves as chancellor of the College of William and Mary. She is shown here during her confirmation hearings with Sen. Barry Goldwater and U.S. Attorney General William French Smith. (AHF Goldwater VIP Collection.)

Three

THE HALLS OF JUSTICE

With a few notorious exceptions involving ropes, justice has primarily been negotiated, argued, and meted out in the hallways, courtrooms, offices, and refreshment centers of the county's distinctive architectural landmarks.

Beginning with the first permanent structure in Phoenix, Captain Hancock's small adobe store at Washington and First Streets, Maricopa County legal history for its first 100 years emanated from downtown Phoenix. Justice courts, presided over by elected justices of the peace, were scattered throughout the county and handled preliminary criminal matters and minor civil disputes. Most major legal activity made its way eventually through the lawyers' offices and state and federal courthouses located in central Phoenix. By 1916, more than 90 percent of Maricopa County's lawyers had offices within walking distance of the county courthouse.

After renting three temporary court facilities in the 1870s and early 1880s, the citizens of Maricopa County reluctantly agreed in 1883 to invest in a permanent courthouse and jail. Although originally authorized by the territorial legislature to build a real courthouse in 1879, and again in 1881, the county Board of Supervisors resisted the legislature's attempts to "force the people of Maricopa County to build a new courthouse against their will." In response, the legislature threatened to ignore the county officials and have a building constructed by a territorial board. The supervisors quickly awarded a contract and issued bonds valued at $30,000 to complete the structure in February 1884.

For the next 45 years, the two-story brick courthouse served the county. In 1929, it was replaced by what is affectionately called the "Old Courthouse" today. The seven-story facility was the nerve center for Maricopa County legal practice until 1965, when the East Court tower opened. Within a few blocks were the federal courthouse and the Arizona Supreme Court.

As the population of Maricopa County became less concentrated in central Phoenix and spread into surrounding communities, regional superior court buildings have been constructed. Supplementing the existing justice courts and municipal courts, new court facilities have opened in Mesa, Northeast Phoenix, and Surprise and are planned for Avondale and Chandler. Downtown justice facilities have expanded to include additional jails, juvenile centers, and records facilities; in all, the courts of Maricopa County now utilize more than 50 buildings. From one division in 1912, the county court system has expanded to include about 150 judges and commissioners by 2007.

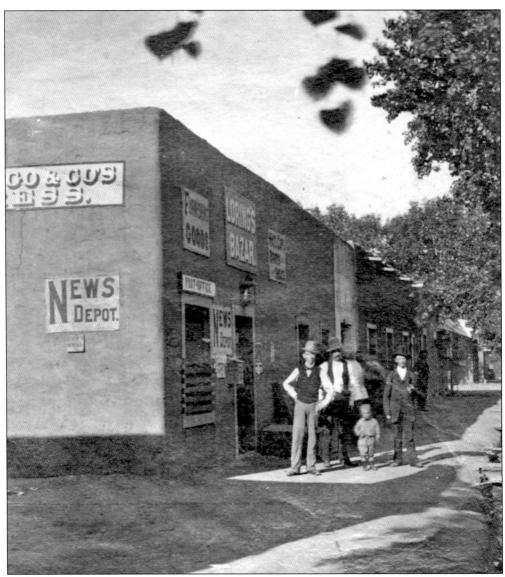

Only three years after the first American settlers arrived in the Salt River Valley, Capt. William A. Hancock purchased a lot on the south side of the newly platted Washington Street between Center and First Streets for $70. Within weeks, adobe bricks were being made for what would become the first permanent structure in Phoenix. Work was begun on the site in January 1871 and completed the next month. Hancock's multi-use development served as post office, store, butcher shop, seat of county government, and temporary courthouse. Maricopa County rented the rear portion of the building for $10 per month. The adobe structure is visible in the middle of the block shown in this photograph. In a clear expression of priorities, the second building erected in Phoenix was a brewery located across Washington and about a block to the east. With beer to drink, a store to frequent, and a place to conduct legal affairs, the growing population of between 500 and 600 souls could wander the 100-foot-wide streets of the new town with pride. (AHF, FPMC-H-385.)

Captain Hancock and his partner, James Monihan, completed construction of the first designated Maricopa County Courthouse, south of Washington on First Avenue, in the summer of 1871 for a total cost of $900. The county rented space in the adobe building for $45 per month. The building was home to the first session of the district court and also the town's first public school. (AHF, FPCRE-127.)

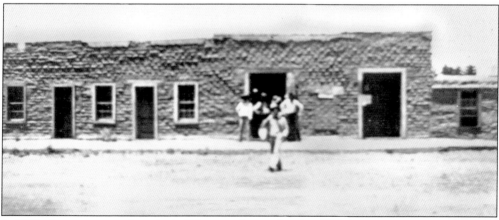

In 1875, the county purchased a building on the south side of Washington to serve as the third location of its courthouse. The building had been constructed by Clemente Romo and operated as a store. Romo was the patriarch of a long-standing Phoenix Hispanic family. (AHF, FPDPX-64.)

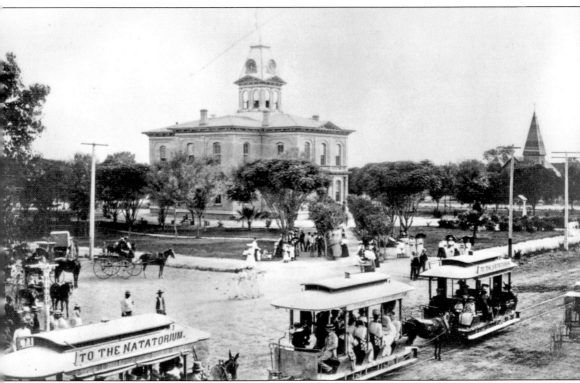

After almost five years of political wrangling, the Maricopa County Board of Supervisors was finally coerced by the territorial legislature into building this fine, two-story brick courthouse in 1884. The structure was located in the center of a square bounded by Washington Street on the north, Jefferson Street on the south, First Avenue (Cortez Street), and Second Avenue (Mojave Street). The project cost $30,000, and $3,500 was allocated for the construction of sidewalks, landscaping, suitable shelving for law books, and courtroom furniture. The building served the county for 45 years. The courthouse also housed the county jail. The clock tower was the tallest structure in town when it was built and was later used to help keep the trolley system running on schedule. (McL, CPMCL-97607.)

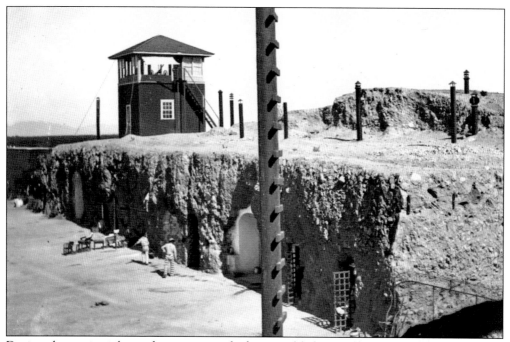

During the territorial era, those convicted of criminal behavior (from adultery to murder) in the courts of Maricopa County found themselves taking up residence in the notorious Yuma Territorial Prison. The culturally diverse inmate population included both males and females. Over 3,000 prisoners were "guests" at the institution between 1876 and 1909, including more than a few lawyers. (RR, CPRR-768 D.)

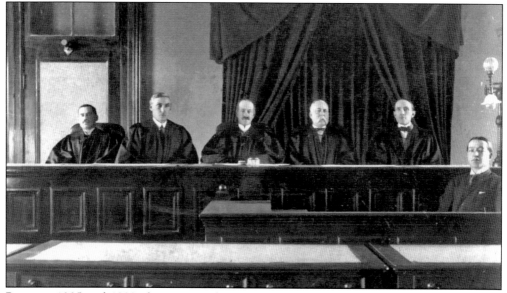

Between 1905 and 1909, the territorial supreme court consisted of, from left to right, John Campbell, Richard Sloan, Edward Kent, Fletcher Doan, and Frederick Nave. Each justice also served as the federal district judge for one of Arizona's five judicial districts. The court met in the territorial capitol. It was not unusual for a justice to hear an appeal of his own lower court decision. Reversal rates were not a big concern. (AA, #95-2501.)

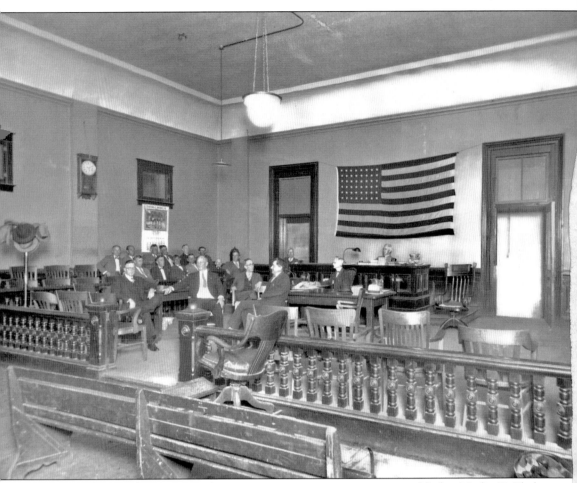

Inside the courthouse, jurors, lawyers, a witness, a court reporter, and Judge Marlin T. Phelps (under the flag) relax after a day's work in the courtroom in December 1927. The courtroom was fully equipped with a heavily laden hat rack, spittoons, and a coal-burning stove. After more than 40 years of service, the space was showing some wear. Judge Phelps served from 1923 to 1948. When he took the bench, he was one of two superior court judges in the county, and when he retired, the number of divisions had increased to seven. After retiring from the superior court with 25 years of service, Phelps sat on the Arizona Supreme Court bench until 1961, with two stints as chief justice. An outspoken critic of judicial activism and a founding member and national director of the John Birch Society, Phelps was characterized by the *Washington Post* as "the high priest of conservatism." (McC, CPMCLMB-A508.)

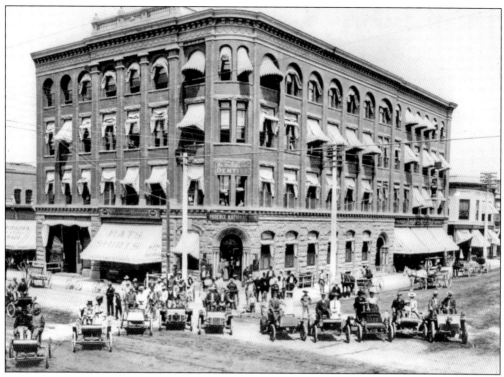

Almost half of the 70 members of the Phoenix Bar in 1916 could be found working from offices in the Fleming Building (above), directly across the street from the courthouse at 16 North First Avenue. Another 20 were a block away, at the corner of Washington Street and Central Avenue in the Goodrich Building or the National Bank of Arizona Building. The remaining legal offices were scattered within a two-block radius. Built in 1883, the Fleming Building had the county's first elevator. (Fennemore Craig P.C.)

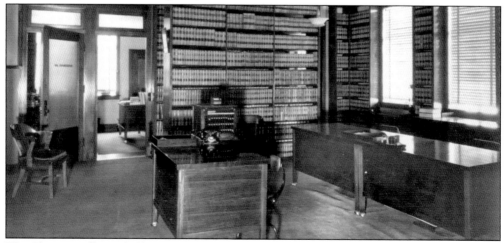

The Phoenix office of Ellinwood and Ross, situated in the Luhrs Tower, became the firm's headquarters in 1929. Primary counsel for Phelps Dodge, the firm was also retained by major railroad and business interests. Originally established in Bisbee in 1910, it represented the defendants in the Bisbee Deportation case. Ellinwood was a former partner of Sara Sorin and her father in Tucson. The firm later evolved into Evans, Kitchell, and Jenckes. (Lu, CPLFPC-512.)

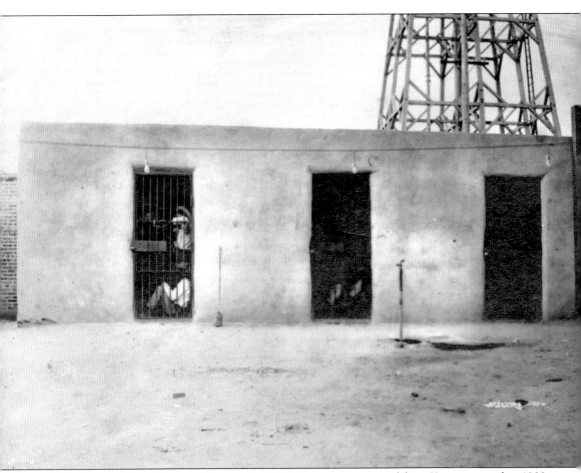

The Arizona State Prison at Florence, built by inmates transported from Yuma, opened in 1908. During construction, the prisoners lived in tents—a precedent for Maricopa County's current Tent City Jail. The new prison facility was generally thought to be a great improvement over the Yuma Territorial Prison. Unlike the territorial prison, it included a new death chamber. Although not located in Maricopa County, the citizens of the county sought and received justice within its walls. Over the years, its prisoners provided low-cost labor for building much-needed state roads and bridges. Until 1968, Florence was the only adult prison in the state. This photograph appears to show early inmates in one of the two original housing wings, which are referred to in some documents as "Pocket" or "Weed." (J. L. B. Alexander Photographs, Arizona Collection, Arizona State University Libraries, CPAL-30.1.)

Florence's death chamber was located one floor above the death row cells. The chamber itself was a scaffold, and in the floor pictured here was a trap door through which the bodies of the hanged fell into a room below. Despite Governor Hunt's adamant opposition to the death penalty and a brief abolition of capital punishment, 28 inmates were executed by hanging between January 5, 1910, and June 20, 1931. (AHF, FPCRE-246.)

After a gruesome decapitation during the hanging of Eva Dugan in 1930, Arizona eventually adopted what was then considered a more humane method of execution: this gas chamber. Lethal injection later became the most-common form of capital punishment. Over 50 inmates have been executed by these more modern methods in the Florence Prison. (AHF, FPCRE-201.)

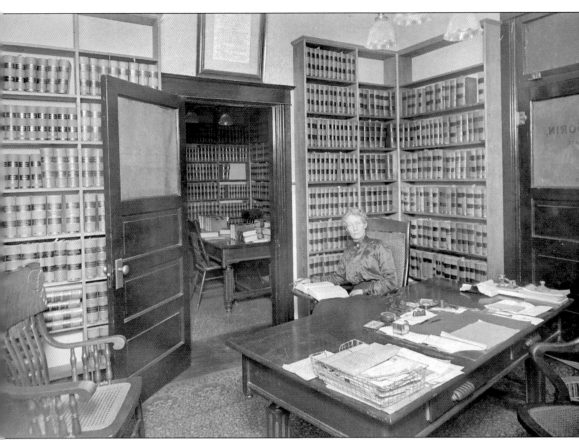

Successful lawyers built their own legal libraries for use in their practices and surrounded themselves with volumes of relevant case law and statutes. Shown here are the impressive law offices of Arizona's first female attorney, Sarah Sorin. Although Sorin practiced in Globe, Maricopa County's attorneys maintained similar work spaces. In 1912, Sorin moved her practice from Tucson to the booming mining town of Globe and became chief legal counsel for the Old Dominion Copper Company. Her crowning legal achievement came in November 1913, in the case of *Work v. United Globe Mines*, when she became the first woman to argue before the U.S. Supreme Court unassisted and unaccompanied by male counsel. At the time, she shared her offices in Globe with future Maricopa County lawyer Alice Birdsall. Sorin won her case in an opinion dated January 5, 1914. Only a few months later, at the age of 53, Sorin died of pneumonia, contracted while traveling to Phoenix by open car to argue before the State Tax Commission. (Arizona Historical Society, Tucson Library Archives, #29361.)

The law office of Phoenix attorney Pearl Hayes (above, center) contained his library, file cabinets, and desk and appears to have been a good place to enjoy a cigar after a hard day litigating. Hayes was a longtime Maricopa County lawyer. In 1912, his suite of two offices sat on the third floor of the National Bank Building (below). Hayes seems to have had a broad practice. In addition to serving as vice president and general counsel for Arizona Corporation Charter Guarantee Company, he represented two plaintiffs in different lawsuits against the railroad appealed all the way to the U.S. Supreme Court. One case, decided in 1931, involved his client's vehicle colliding with a train and the client being denied damages due to contributory negligence. In the other, a 1919 case, Hayes's client sought damages for injuries to his dairy cows, though he failed to give the railroad notice within the required 10 days. Unfortunately the clients lost in both instances. (Above, AHF, FPPF-19; below, AHF, Goldwater Historic Photographs.)

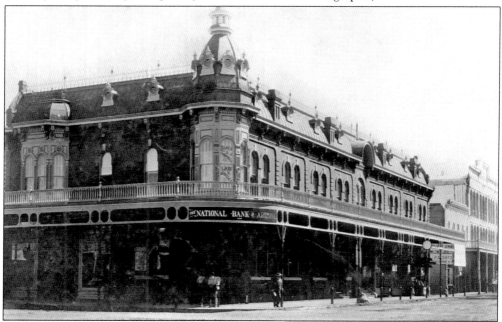

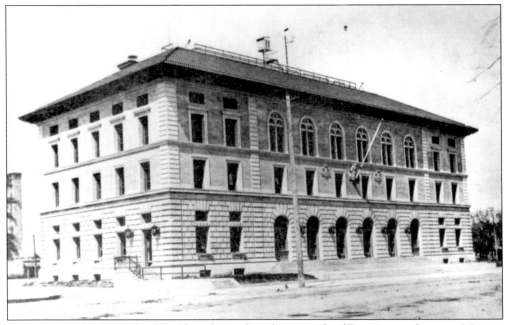

Built in 1913, the first Federal Building, located on the west side of First Avenue between Monroe and Van Buren Streets, housed the post office and other federal offices, including the federal courts. The new building was finished just in time to be occupied by the second judge for the newly created district of Arizona, William Henry Sawtelle. (AHF, FPCRE-112.)

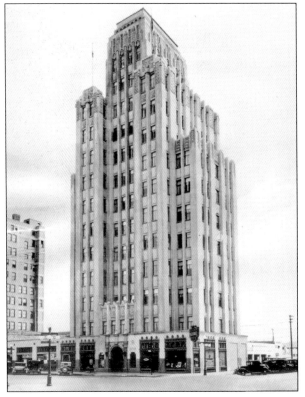

With the 1929 completion of the Luhrs Tower, shown here, many Phoenix lawyers relocated to office space in the tallest and most modern structure in Arizona. Standing on the southeast corner of Jefferson Street and First Avenue, the Luhrs Tower was close to the courthouse and offered a commanding view of the growing valley. Many law offices are still located here. (Lu, CPLFPC-486.)

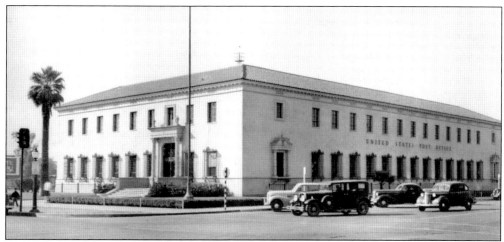

The old Federal Building was replaced in 1936. Standing at 522 North Central Avenue, the new structure contained the federal courts and the main Phoenix Post Office for over 30 years. For the entire period of its use as a courthouse, the building was home to one of Arizona's two federal judgeships. (Jeremy Rowe Photographs, Arizona Collection, Arizona State University Libraries, CPSPC-63:53.)

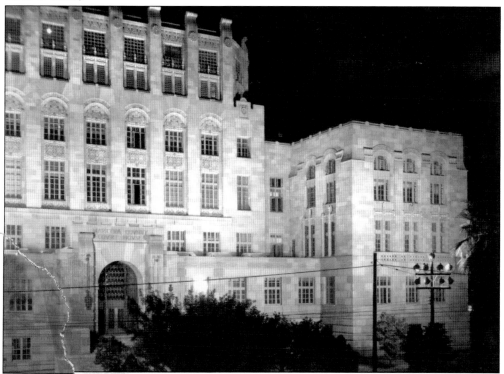

On October 21, 1929, Maricopa County dedicated a new courthouse on the grounds of the old 1884 structure. The impressive ceremonies that marked the opening of the $1.5 million city-county administration building were joined with the international celebration of the 50th anniversary of Thomas Edison's invention of the incandescent lamp. According to the *Arizona Republican*, the courthouse dedication was held at 8:00 p.m., under the illumination of "the almost sunlight brilliance of a great battery of floodlights." (McC, CPMCLMB-A628.)

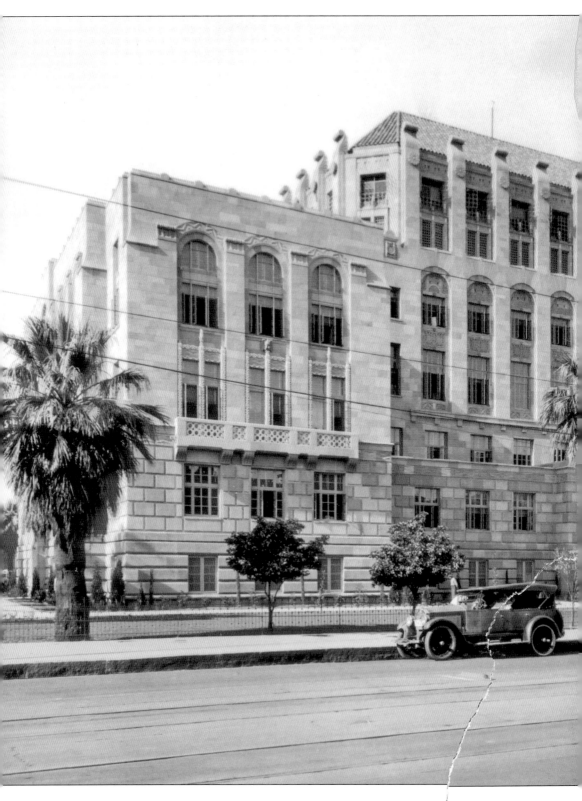

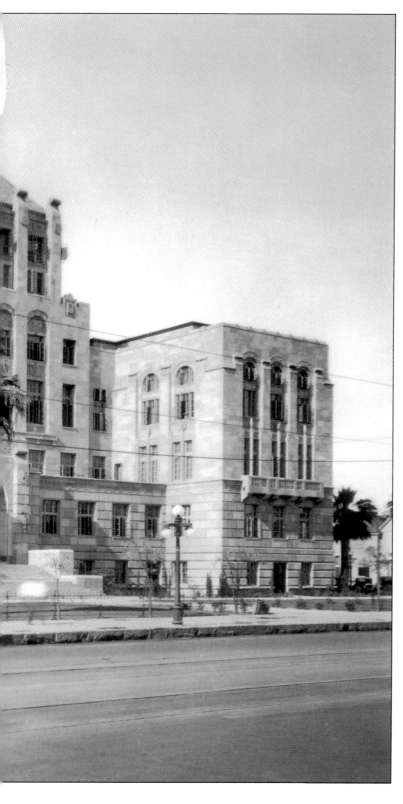

Boy Scouts blocked traffic on Washington Street between Central and Third Avenues to accommodate the crowd of almost 7,000 gathered for the celebration of the new courthouse. Starting at 7:00 that evening, the surging crowd was allowed to tour the new building. Visitors were greeted by city and county officials, department heads, and their staffs. Every room in the new building was lighted with Edison's incandescent bulbs, and each courtroom and office was filled with flowers. The jail on the upper floors that night contained the largest number of prisoners ever held in a Maricopa County jail up to that time: 223 inmates, including 23 women. Fascinated visitors stood in long lines as the new elevator operated nonstop to carry them to the packed sixth- and seventh-floor cell blocks. (McC, CPMCLMB-A627.)

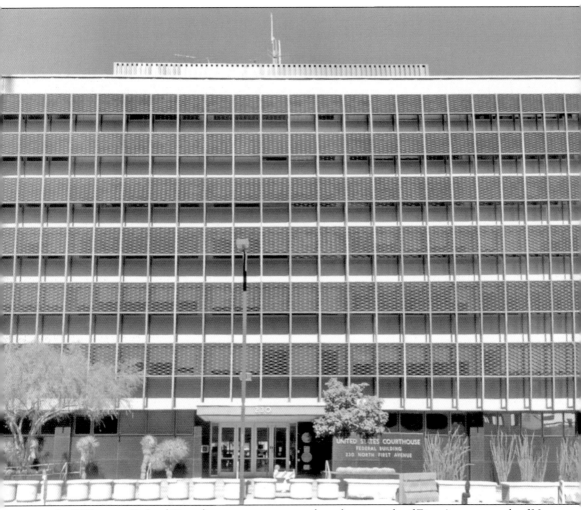

In 1961, a new Federal Courthouse was constructed on the west side of First Avenue, south of Van Buren Street. The building accommodated the growing district of Arizona bench, plus magistrates and resident judges of the Ninth Circuit. (Amy Richardson.)

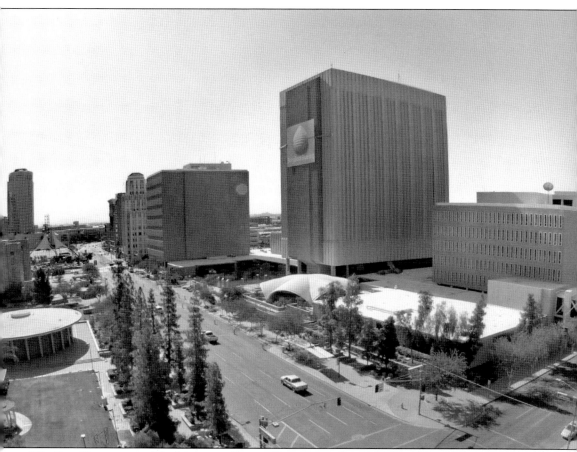
The East Court tower of the Maricopa County Court opened in 1965. It was soon followed by the remainder of the complex, which now houses, along with the old courthouse, about 52 divisions of the superior court, 26 commissioners, and related services. (Amy Richardson.)

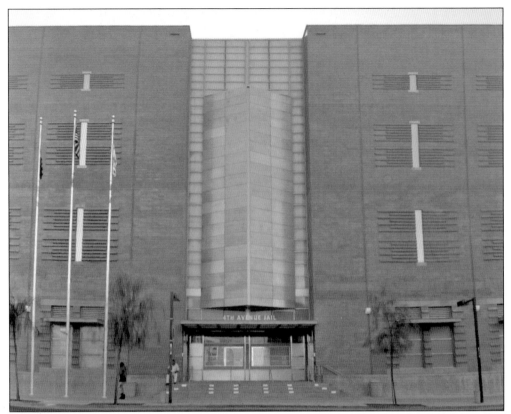

The Fourth Avenue Jail opened in April 2005 with a capacity of over 2,000 inmates. This state-of-the-art facility is considered one of the most secure and technologically advanced in the country. It was also part of the largest county jail expansion project in the history of the nation. (Amy Richardson.)

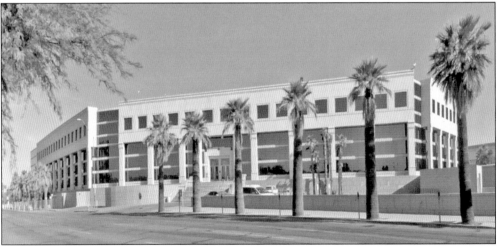

The Arizona State Courts Building started operations at 1501 West Washington in early 1991. This building serves as the seat of Division One of the Arizona Court of Appeals and the Arizona Supreme Court. Maricopa County's lawyers are frequent participants in the proceedings of these courts as judges, justices, and advocates. (Amy Richardson.)

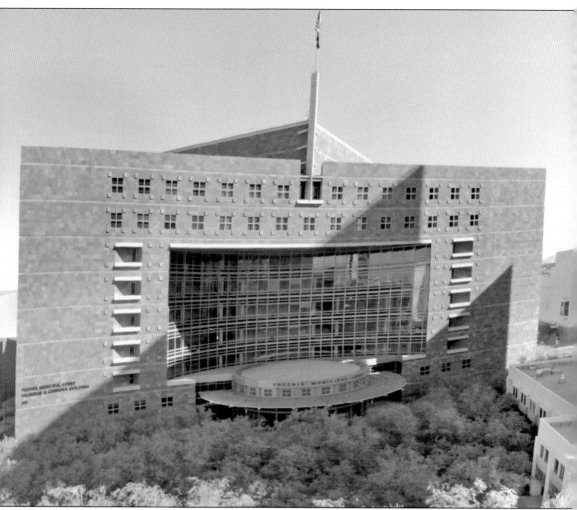

The Valdamar A. Cordova Phoenix Municipal Courthouse, situated at Third Avenue and Washington Street, opened in December 1999. The courthouse serves 590 employees, who work in the municipal court, prosecutor's office, public defender's office, and police department. The total project budget for the modern building was $77.8 million. (Amy Richardson.)

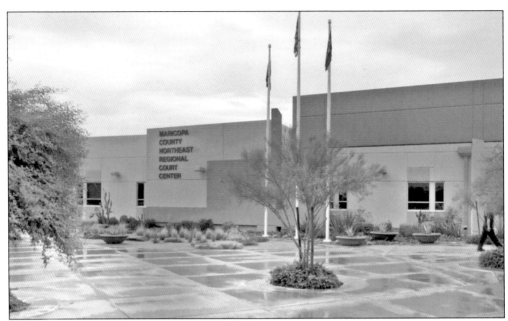

Opening in 2005, the Northeast Regional Court facility stands just south of Union Hills Drive and Highway 51. This building is home to three commissioners and seven divisions of the superior court. (Author's collection.)

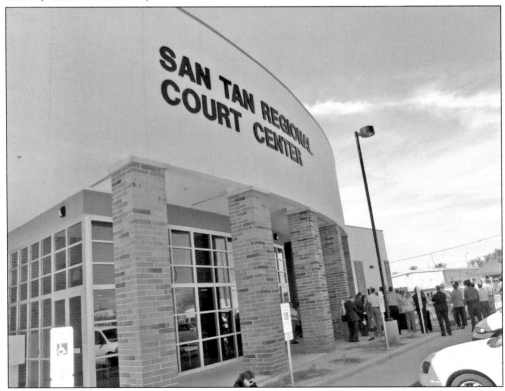

The San Tan Regional Court Center is located in Chandler. This courthouse, which began proceedings in March 2007, includes four Southeast Valley Justice of the Peace courts. (MCSC.)

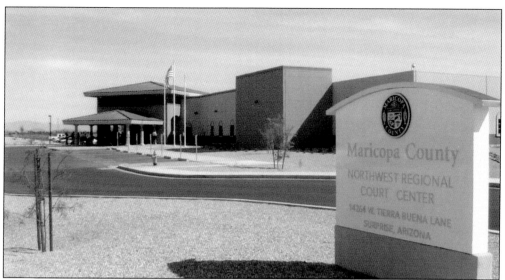

The Northwest Regional Court facility opened in Surprise in 2002. As of 2006, four justice courts shared the facility with the four superior court divisions that operated here. (MCSC.)

The clerk of the superior court has maintained records of the courts since the county was created in 1871. In this facility, lawyers and the public can review case files and obtain copies of important legal filings. Case files for more than 3.5 million matters are managed by the clerk's office. All new cases are digitally scanned and stored electronically. (Amy Richardson.)

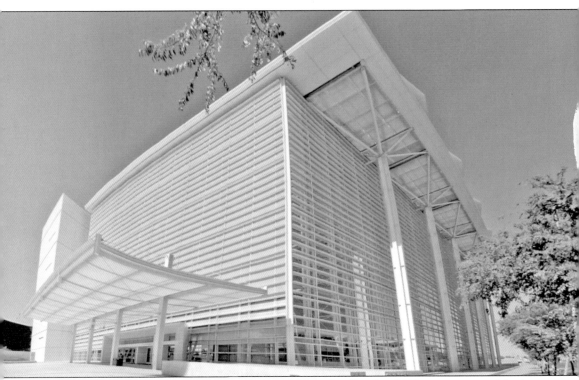

The Sandra Day O'Connor U.S. Courthouse, dedicated in October 2000, was recognized for design excellence by the General Services Administration—its owner. The modern glass-and-metal structure features an atrium with a sculpture of Justice O'Connor, surrounded by 15 courtrooms, a large special proceedings courtroom, and offices for legal, marshal, and court services. This aesthetically dramatic courthouse has had its share of controversy adapting to its desert setting, but it remains an architecturally distinctive legal landmark in the county. (Amy Richardson.)

Four

CASE HISTORY

Every case is important to the litigants and lawyers involved, but some transcend the parties to impact the broader legal, social, and commercial framework of society. Maricopa County lawyers have played roles in many significant cases that have dramatically influenced our daily lives.

In the desert of central Arizona, nothing is more important than water. In the early years of Maricopa County, courts were called upon to define water rights and establish a system of water law that would permit the Salt River Valley to flourish agriculturally. Maricopa County lawyers later waged a decades-long battle over Arizona's entitlement to the waters of the Colorado River. The prosperity of the region today is a direct result of the water law cases highlighted in this chapter.

The legal tradition of the county is also strongly influenced by its nationally important, cutting-edge cases involving civil rights of minorities, criminals, and immigrants; economic rights of women; and changing norms for the practice of law. From the early days of statehood, disputes concerning residents and lawyers of Maricopa County have been litigated to the U.S. Supreme Court and have become foundational precedents for the extension of civil and economic rights and the limitation of governmental powers.

Finally, over the years Maricopa County has been fertile ground for a share of gruesome and high-profile crimes. The prosecutions of Arizona's accused murderers, villains, corrupt politicians, and others have been fodder for national tabloids. Colorful criminals, determined lawmen, and the remnants of a lawless past have combined to produce criminal cases that stirred the public's imagination.

From determining the rights of an immigrant restaurant employee, to prosecuting the "Trunk Murderess," to waging an epic battle with California and other states for the water needed to quench the growing state's thirst, Maricopa County lawyers have performed with distinction on a national legal stage.

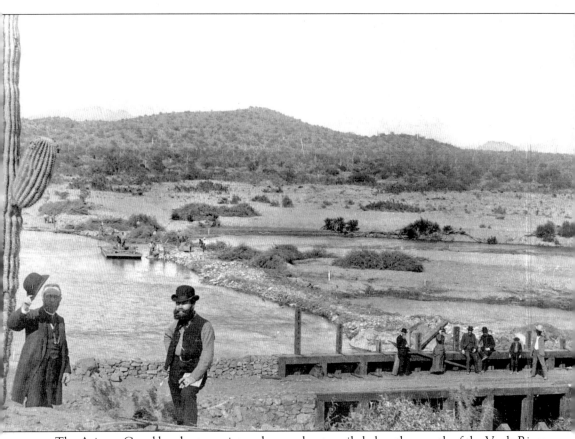

The Arizona Canal headwaters, pictured, were about a mile below the mouth of the Verde River on the Salt River. The diversion dam, completed in 1883, was rebuilt after being destroyed by a flood in 1886. Here men work in the background while George P. Dykes (with the dark beard) enjoys a cigar. The major investments necessary to undertake projects like the Arizona Canal were initially funded by bonds sold to investors around the country, in anticipation of profits from future sales of land and water rights to settlers. Farmers had also cooperated to build canals for their own use. By the late 1880s, water from the valley's rivers had been over-appropriated, and the issue of who owned the precious resource soon became explosive. (AHF, FPCRE-288.)

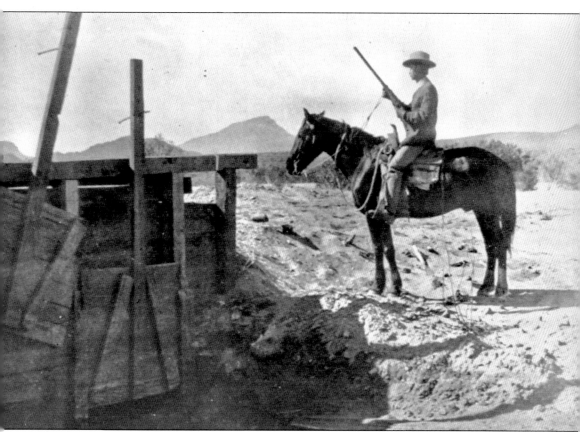

In the 1870s, Michael Wormser, an opportunistic Prescott merchant, loaned money to the Mexican farmers who settled on the south side of the Salt River. The farmers also received financing from Wormser for improvements to the San Francisco Canal, which they had built. When the farmers were eventually unable to repay their debts, Wormser acquired at least 9,000 acres of prime farmland through foreclosures. In *Wormser v. Salt River Valley Canal Company*, Judge Kibbey issued a decree that established water rights for nearly half the irrigated land in Arizona. His 1892 decision recognized that water rights were attached to the land and not controlled by the canal companies, and that earlier users had priority over later arrivals. Kibbey's Doctrine of Prior Appropriation established a stable basis for agricultural development in the valley. In this image, a guard protects access to the "liquid gold" of the Salt River. (McL, CPMCL-97743.)

In the 1890s, the *Phoenix Herald* reported that the parched desert of the Salt River Valley was becoming a "land of the vine, the fig, the date, the olive, the apple, pear, peach, nectarine, apricot, and pomegranate—the land of oil, wine, raisins, preserved and dried fruits in which there was untold wealth." Once a determination was made by the federal government to construct Roosevelt Dam, the stakes in continuing water rights disputes increased dramatically. After two and a half years of testimony in *Hurley v. Abbott*, Judge Edward Kent issued a decree based on principles established by Judge Kibbey in *Wormser* that clarified and established the relative water rights of all users up to that time. The Kent Decree has governed water use in the valley ever since. In *Hurley*, Judge Kibbey represented the prevailing water users' association. (Above, AHF, FPCRE-301; below, AHF, FPCRE-262.)

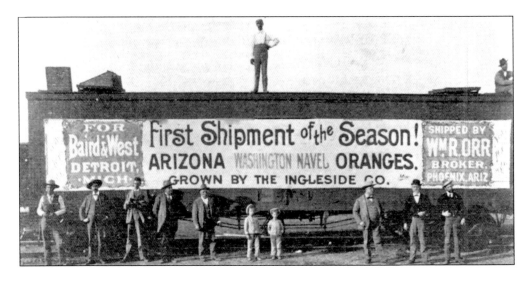

Arizona voters approved the "80 Percent Law" in late 1914. Under this statute, employers were prohibited from employing less than 80 percent qualified electors or native-born citizens. Mike Raich was an Austrian cook in the English Kitchen, a Bisbee restaurant similar to that in the above photograph. He challenged the constitutionality of the new law and sought an injunction preventing the state from prosecuting his employer under the statute. The case, argued by Maricopa County lawyer, Arizona attorney general, and named defendant Wyley Jones (right), would become Arizona's first "landmark" U.S. Supreme Court decision and would establish a civil rights and immigration law precedent still relied on by the courts. The *Raich v. Truax* opinion established that the equal protection guaranteed by the 14th Amendment protects the right of an individual to work in his/her chosen profession and that the authority to control immigration is vested solely in the federal government. (Above, AHF, RS-30; right, AA, #97-6638.)

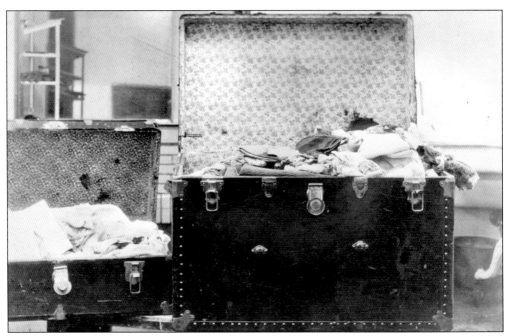

In one of the most sensational murder trials of the 1930s, Winnie Ruth Judd was convicted of the murder of Agnes LeRoi. Judd allegedly shot LeRoi and another friend in an argument over the three women's romantic involvement with a married man. After the shootings, one of the victims was dismembered and both bodies were loaded into a large packer trunk. When Judd was told that the large trunk was too heavy to ship by rail to Los Angeles, she shifted various body parts into a second steamer trunk, a valise, and a hat box. Suspicions were aroused when the shipped trunks began to leak and emit an unpleasant odor. Judd arrived to claim the trunks at union station but escaped, becoming the subject of an intensive manhunt. (Above, McL, CPMCL-92107; below, McL, CPMCL-92113.)

WANTED For Double Murder. Murdered and mutilated two young women at Phoenix Ariz. Oct. 16, 1931. WINNIE RUTH JUDD — Mrs. Judd will no doubt represent herself to be a professional nurse — She has a very pleasing personality, rather slender build, slim legs and thick hair — Age 25 — Height 5ft 7 inches — Weight 125 — Eyes Blue grey and large — Hair Light brown —

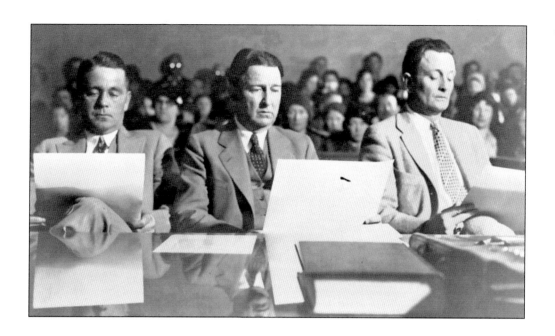

The sordid affair captured headlines across the country, and Judd became infamous as the "Trunk Murderess." After Judd's capture in Los Angeles and subsequent return to Phoenix, the trial was held before Judge Howard Speakman in a standing-room-only courtroom packed with an eager press corps. Judd, who did not testify in her own defense, was convicted and sentenced to hang. Maricopa County sheriff John McFadden (below, in bow tie and to the left of the calendar) believed that Judd was covering for her former lover. Through a subsequent grand jury hearing in which Judd told her side of the story and a less-than-thorough insanity hearing, McFadden helped her avoid the gallows. Judd was committed to the Arizona State Mental Hospital and, during her more-than-30-year incarceration, escaped on six different occasions. Over a year after attorney Melvin Belli argued before the parole board for her release, Judd's sentence was commuted; she was freed in 1971. Above is the prosecution team, and below Judge Speakman addresses the defense counsel. (Above, McL, CPMCL-92103; below, McL, CPMCL-92104.)

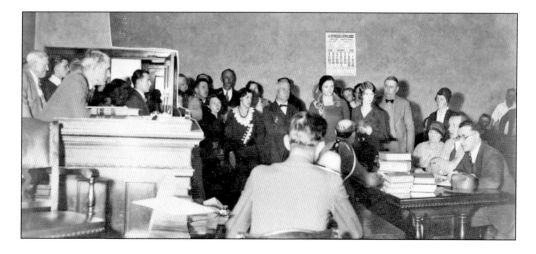

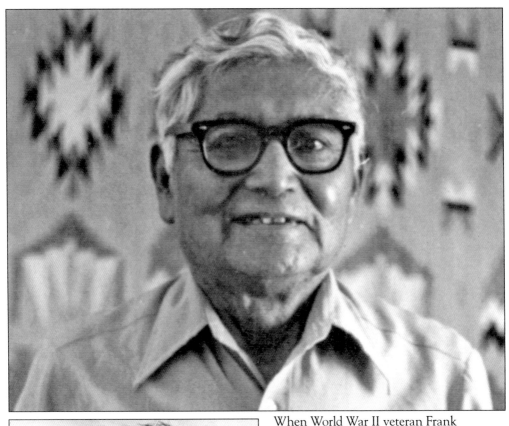

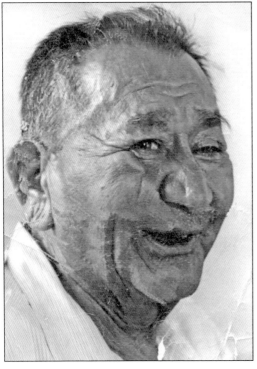

When World War II veteran Frank Harrison (above) and tribal chairman Harry Austin (left), both tribal members and residents of the Fort McDowell Yavapai Nation, were denied the right to register to vote in the Maricopa County elections of 1948, Arizona was one of the few remaining states still refusing Native Americans suffrage. At the time, an Arizona constitutional provision prohibiting those "under guardianship" from being eligible to vote was applied to tribal members, as they were considered wards of the federal government. The Arizona Supreme Court, in *Harrison v. Laveen*, reversed this long-standing precedent. Under pressure from the ACLU, the National Congress of American Indians, and the President's Committee on Civil Rights, and with the support of an amicus curiae brief by the famous Native American law expert Felix Cohen, the court reinterpreted the state constitution to correct what it admitted was a "grave injustice." (Fort McDowell Yavapai Nation.)

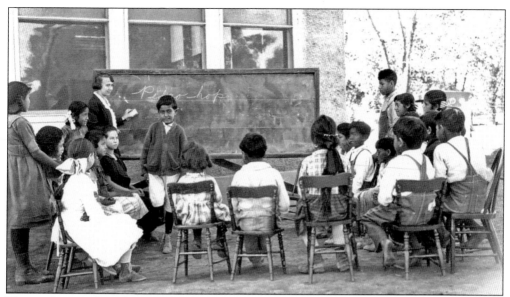

Phoenix lawyers Greg Garcia and Ralph Estrada, supported by the Comite Moviemiento Mexicana Contra la Discriminacion (below), challenged the "separate but equal" doctrine in *Gonzales v. Sheely*. This 1951 civil rights class-action case struck down Tolleson Elementary School District's practice of segregating Hispanic students by forcing them to attend schools "reserved for and attended solely and exclusively by children and persons of Mexican or Latin descent." The school district justified its practice based on potential English language deficiencies of some Hispanic children, but the federal district court determined that such deficiencies, if they existed at all, might justify different "pedagogical methods of instruction" but not "the general and continuous segregation . . . of children of Mexican ancestry." Pictured above is a segregated elementary school class in Tempe in 1926. (Above, UAP, ASUD-T72.R8-14; below, Sonny Pena Photograph, Chicano Research Collection, ASU Libraries, MPSPC-317:1.)

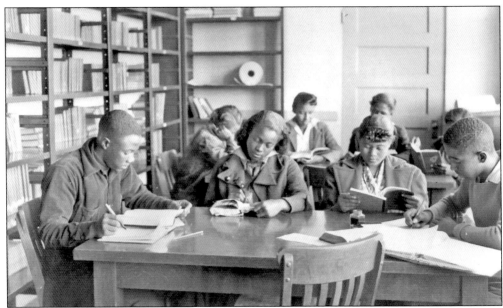

Declaring that there are "no second class citizens in Arizona," superior court judge Fred C. Struckmeyer Jr. found that Phoenix Union High School District's refusal to admit African American students to Phoenix Union and West High was unconstitutional. In *Phillips v. Phoenix Union High School District*, attorneys Hayzel B. Daniel, Herbert Finn, and Stewart Udall represented three African American students forced to attend segregated Carver High School (above and below). Some 14 months before the U.S. Supreme Court decided *Brown v. Board of Education*, Struckmeyer issued his ruling striking down Arizona's statute permitting segregation. The case was appealed but later dismissed by the Arizona Supreme Court as moot because the school district had voluntarily closed Carver and integrated its high schools. The litigators reinforced their success in *Heard v. Davis*, during which Judge Bernstein ruled segregation unconstitutional. (Above, AA, #96-1654; below, George Washington Carver Museum and Cultural Center.)

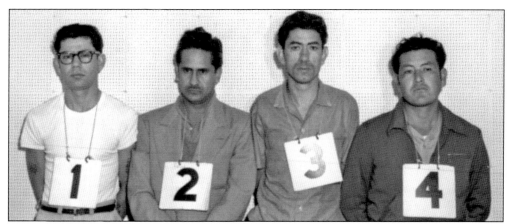

It was shortly after 11:00 on a Saturday night in 1963 when the war epic *The Longest Day* finally finished and the young woman running the concession stand closed up the Paramount Theatre in downtown Phoenix. While walking from her bus stop, the 18-year-old was approached by a stranger, who forced her into the back seat of his car and drove to the desert, where he raped and robbed her. The victim tentatively identified Ernesto Miranda (No. 1, above) in a lineup 10 days later, and Miranda confessed to the crime after a short interrogation. Miranda's court-appointed trial lawyer, 73-year-old Alvin Moore, objected to the admission of Miranda's confession but was overruled, and Miranda was convicted. (Above, AA, #97-7381; below, AA, #97-7385.)

IN THE

Supreme Court of the United States

OCTOBER TERM, 1968

———

No.

———

ERNESTO A. MIRANDA, Petitioner,

v.

STATE OF ARIZONA, Respondent.

———

PETITION FOR WRIT OF CERTIORARI TO THE
SUPREME COURT OF ARIZONA

———

LEWIS ROCA BEAUCHAMP & LINTON
114 West Adams Street
Phoenix, Arizona

By JOHN P. FRANK
JOHN J. FLYNN
PAUL G. ULRICH

Counsel for Petitioner

Moore unsuccessfully appealed what he argued was a denial of Miranda's Fifth and Sixth Amendment rights to the Arizona Supreme Court. Moore declined representing Miranda in his appeal to the U.S. Supreme Court because of health reasons, and so the ACLU convinced a team of Lewis and Roca attorneys, including John Flynn, John Frank, Paul Ulrich, and Peter Baird, to handle it. The team drafted a short, 2,500-word request for writ of certiorari (left) focused on Frank's arguments that Miranda's Sixth Amendment right to counsel had been violated. The high court agreed to hear the case and eventually ruled in Miranda's favor. As a consequence, law enforcement officers around the country—and those playing them on television—were issued Miranda warning cards that ensured suspects were informed of their constitutional rights before interrogation (below). (Peter Baird, Lewis and Roca, LLP.)

YOU HAVE THE RIGHT TO REMAIN SILENT.

ANYTHING YOU SAY CAN BE USED AGAINST YOU IN A COURT OF LAW.

YOU HAVE THE RIGHT TO THE PRESENCE OF AN ATTORNEY TO ASSIST YOU PRIOR TO QUESTIONING, AND TO BE WITH YOU DURING QUESTIONING, IF YOU SO DESIRE.

IF YOU CANNOT AFFORD AN ATTORNEY YOU HAVE THE RIGHT TO HAVE AN ATTORNEY APPOINTED FOR YOU PRIOR TO QUESTIONING.

DO YOU UNDERSTAND THESE RIGHTS?

WILL YOU VOLUNTARILY ANSWER MY QUESTIONS?

6-13-66

In 1967, Sara Baird graduated from Stanford University Law School and received the top score on the Arizona Bar Examination. However, the bar denied her admission because she refused to answer application question No. 27, shown below. In her appeal to the U.S. Supreme Court, *Baird v. State Bar of Arizona*, Sara was represented by her 28-year-old husband, Peter Baird, assisted by John Frank, and the bar was represented by renowned trial lawyer Mark Wilmer. The case was argued twice to the Supreme Court, and Sara Baird eventually prevailed—the court concluded that the First Amendment prohibits a state from excluding someone from a profession solely because of membership in a political organization or a personal belief. (Above, UAP, UPASUG-S8861970s#5; below, Peter Baird, Lewis and Roca, LLP.)

27. Are you now or have you ever been a member of the Communist Party or any organization that advocates overthrow of the United States Government by force or violence?

On the morning of his eighth wedding anniversary in 1976, *Arizona Republic* investigative reporter Don Bolles (left) drove to the Clarendon Hotel in midtown Phoenix to meet with a man who had information about a land deal involving local politicians. When the informant did not show up, Bolles returned to his car and started to drive away. A bomb attached to the car (below) was detonated, killing the reporter and setting off a firestorm of media attention and investigations that eventually resulted in the convictions of John Harvey Adamson, a racing dog owner and former tow truck operator; Max Dunlap, a Phoenix contractor; and James Robison, a Chandler plumber. Fingers were pointed at other influential citizens, including a local attorney; convictions of all three were overturned, though multiple trials and appeals kept the case alive for decades. (*Arizona Republic* June 2, 1976. Used with permission. Permission does not imply endorsement.)

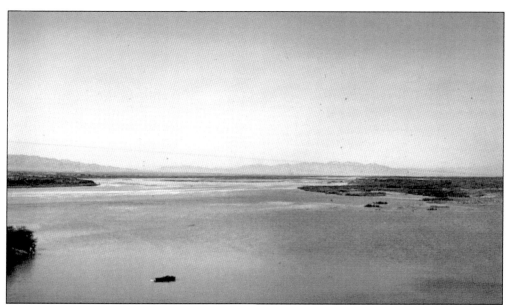

Beginning in the early 1920s and continuing more than 30 years, the thirsty Southwestern states constituting the drainage basin of the Colorado River (above) battled over the river's priceless water. Negotiations for allocations from the river intensified when the federal government decided to build dams along the lower Colorado and an All-American canal to deliver water to California's fertile Imperial Valley. After numerous failed congressional attempts and voluntary interstate compacts (the 1922 compact is pictured at right), in 1952, Arizona invoked the original jurisdiction of the U.S. Supreme Court by filing *Arizona v. California* to determine each state's legal right to the river water. The court appointed a special master to take evidence, find facts, state conclusions of law, and recommend a decree, subject to consideration and approval by the court. (Above, LoC, LC-DIG-fsac-1a34756; right, ASU.)

```
                COLORADO RIVER COMPACT
                SIGNED AT SANTA FE, N. MEX.
                     November 24, 1922

     The States of Arizona, California, Colorado, Nevada, New Mexico, Utah and Wyom-
ing, having resolved to enter into a compact under the act of the Congress of the
United States of America approved August 19, 1921 (42 Stat. L., p. 171), and the
acts of the legislatures of the said States, have through their governors appointed
as their commissioners: W. S. Norviel for the State of Arizona, W. F. McClure for
the State of California, Delph E. Carpenter for the State of Colorado, J. G. Scrug-
ham for the State of Nevada, Stephen B. Davis, Jr., for the State of New Mexico,
R. E. Caldwell for the State of Utah, Frank C. Emerson for the State of Wyoming, who
after negotiations participated in by Herbert Hoover, appointed by the President as
the representative of the United States of America, have agreed upon the following
articles.

                              ARTICLE I

     The major purposes of this compact are to provide for the equitable division
and apportionment of the use of the waters of the Colorado River system; to estab-
lish the relative importance of different beneficial uses of water; to promote in-
terstate comity; to remove causes of present and future controversies and to secure
the expeditious agricultural and industrial development of the Colorado River Basin,
the storage of its water and the protection of life and property from floods. To
these ends the Colorado River Basin is divided into two basins, and an apportionment
of the use of part of the water of the Colorado River system is made to each of them
with the provision that further equitable apportionment may be made.

                                NOTES

     PERMISSION FOR COMPACT -- Congress, in the Act of August 19, 1921, 42 Stat.
171, consented to a compact between the States of Arizona, California, Colorado,
Nevada, New Mexico, Utah and Wyoming, respecting the disposition and apportionment
of the waters of the Colorado River.

     TRANSMOUNTAIN DIVERSION OF COLORADO RIVER WATER -- The Colorado River compact

                                 -1-
```

In the Supreme Court of the United States

OCTOBER TERM, 1960

STATE OF ARIZONA, COMPLAINANT

v.

STATE OF CALIFORNIA, PALO VERDE IRRIGATION DISTRICT, IMPERIAL IRRIGATION DISTRICT, COACHELLA VALLEY COUNTY WATER DISTRICT, METROPOLITAN WATER DISTRICT OF SOUTHERN CALIFORNIA, CITY OF LOS ANGELES, CALIFORNIA, CITY OF SAN DIEGO, CALIFORNIA, AND COUNTY OF SAN DIEGO, CALIFORNIA, DEFENDANTS

THE UNITED STATES OF AMERICA AND STATE OF NEVADA, INTERVENERS

STATE OF UTAH AND STATE OF NEW MEXICO, IMPLEADED DEFENDANTS

Simon H. Rifkind, *Special Master*
REPORT

December 5, 1960

Arizona was represented in this epic water contest by respected trial lawyer Mark Wilmer. Wilmer's research uncovered an obscure statute that he interpreted in Arizona's favor. The trial in *Arizona v. California* lasted over two years, during which testimony was received from 340 witnesses and over 25,000 pages of transcripts were filled. The special master's 433-page report (left) was transmitted to the U.S. Supreme Court in 1961. The case was extensively briefed, orally argued on two occasions for a total of more than 22 hours, and finally decided in June 1963—11 years after it was filed. Wilmer's arguments prevailed, and Arizona's entitlement to Colorado River water was secured. As a direct result of this victory, Pres. Lyndon Johnson signed legislation in 1968 authorizing construction of the Central Arizona Project (below). (Above, ASU; below, Snell and Wilmer, LLP.)

In 1975, Nathalie Norris (right), an employee of the Arizona Department of Economic Security, elected to participate in a deferred compensation retirement plan offered by the state. Her contributions to the plan were equivalent to male employees; however, based on actuarial rationalizations, females received a lower payout from the plan than male retirees. Phoenix attorney Amy Jo Gittler of the Arizona Center for Law in the Public Interest argued for Norris in *Arizona Governing Committee v. Norris* to the U.S. Supreme Court and was successful in convincing the court that unequal retirement benefits for women violated Title VII of the Civil Rights Act of 1964. The court noted, in its landmark opinion, that actuarial distinctions between the sexes were not a valid rationale for unequal benefits. *Norris* brought women another step along the path to workplace equality that had begun in Arizona in 1923 with Governor Hunt's signing of the Women's Minimum Wage Law (above). (Above, AA, #01-2119; right, Arizona Business and Professional Women's Foundation.)

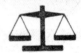

After a few years of struggling to provide routine services to the public at modest fees through their legal clinic, John Bates and Van O'Steen (above) determined that their practice depended on representing a substantial volume of clients. To generate the necessary flow of business and test bar ethics rules, the partners placed an advertisement in the *Arizona Republic* in February 1976 (right). The advertisement was in direct conflict with Rule 2-101(B) of the Arizona Supreme Court disciplinary rules, and the state bar undertook proceedings against the lawyers. In *Bates v. State Bar of Arizona*, the U.S. Supreme Court decided that the rule restricting the attorneys' commercial speech was not subject to attack under the Sherman Antitrust Act, but that it did violate the First Amendment. The court's opinion opened the door for today's pervasive lawyer advertising. (O'Steen and Harrison, PLC.)

DO YOU NEED A LAWYER?

LEGAL SERVICES AT VERY REASONABLE FEES

* Divorce or legal separation--uncontested (both spouses sign papers)
 $175.00 plus $20.00 court filing fee

* Preparation of all court papers and instructions on how to do your own simple uncontested divorce.
 $100.00

* Adoption--uncontested severance proceeding
 $225.00 plus approximately $10.00 publication cost.

* Bankruptcy--non-business, no contested proceedings
 Individual
 $250.00 plus $55.00 court filing fee
 Wife and Husband
 $300.00 plus $110.00 court filing fee

* Change of Name
 $95.00 plus $20.00 court filing fee

Information regarding other types of cases furnished on request

Legal Clinic of Bates & O'Steen
617 North 3rd Street
Phoenix, Arizona 85004
Telephone (602) 252-8888

Five

ALL WORK AND NO PLAY

The lawyers of Maricopa County have traditionally been a hard-working group, but with a healthy dose of balance and common sense. For most of the first 45 years that attorneys practiced their profession in the Salt River Valley, the courts adopted the very sensible practice of avoiding scheduling of trials or other court hearings during the torrid summer months.

Federal court sessions were originally held only in April and October. Barring unusual circumstances, the superior court closed in July and August every year, until Judge Frank Lyman determined in June 1916 that the docket was getting out of control and summer court was needed to address the caseload. Even after Judge Lyman's precedent-setting decision, most lawyers, like the rest of the valley's wealthier citizens, still managed a summertime escape from the over-100-degree temperatures. Until the advent of air-conditioning, nothing close to business as usual could be conducted in the summer.

Besides annual or more frequent escapes to cooler climes (the mountains, the beach, or even back East), local attorneys and their families were full-time participants in the social and recreational life of the region. From Arizona's first attorney general's fascination with automobile racing, to Judge/Governor Phillips's love of fishing and hunting, to Raphael Estrada's and Hayzel Daniels's interest and participation in sports, to the Barrister's Ball, the legal community has shared the hobbies, interests, and entertainments of clients and neighbors.

From the beginning, area lawyers have mixed their legal business with pleasure—lunch and dinner meetings with clients, golf outings, strategy sessions over a cool beverage, and getaways to the local resorts and clubs. The history of Maricopa County law must include the social climate of the valley that its legal community helped create, as it has served as an important context for the actual business of law.

Sometimes lawyers just want to have fun.

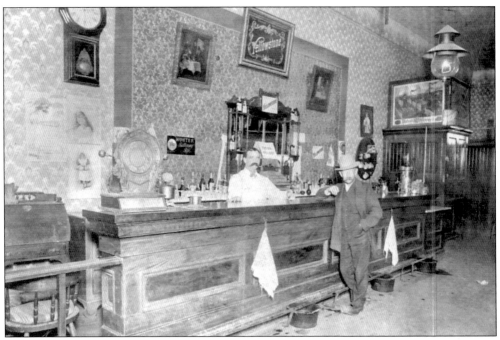

Whether for relieving stress, lubricating throats dried by hours of argument, drowning sorrows, celebrating victories, or other reasons known only to experienced barkeeps, more than a few saloons stood in close proximity to the courthouse. Lawyers, judges, litigants, jurors, and other court-related characters did not have to go far to satisfy their thirsts on Washington Street. (AHF, CRE-63.)

The Wellington Bar appears to have catered to a more upscale clientele. Bartender Charles Sterner offered a wide selection of cigars in addition to the beers on tap and other potables. Note the clean towels for patrons and the gargoyle-like supports for the bar. (AHF, CRE-54.)

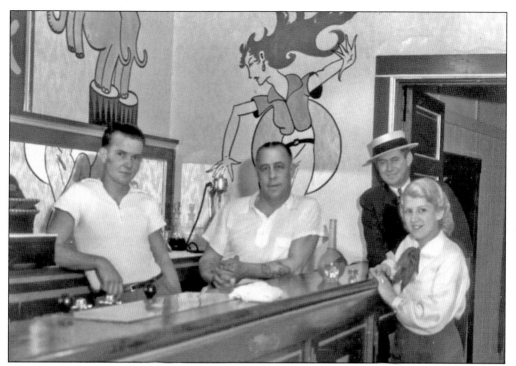

Only during the long years of Prohibition (beginning in Arizona in 1916 and continuing through 1933) did the downtown watering holes frequented by the legal community close—or at least appear to close—their doors. Hidden speakeasies and private clubs, such as the one pictured here, were able to partially fill this gap in services to the legal community and others. (Ly, CPSPC-57:55.)

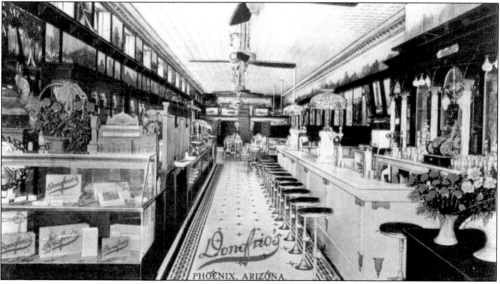

During warmer times of year, a thirsty lawyer could find delicious temporary relief from the rising temperatures only a few steps from the courthouse. The Elvey and Hulett Drug Store soda fountain and the Owl Drug offered a cold root beer for a nickel and a shoe shine for the same price. Donofrio's Candy and Ice Cream Store, on the south side of Washington Street near First Avenue, also boasted a busy soda fountain. (AHF, CRE-38.)

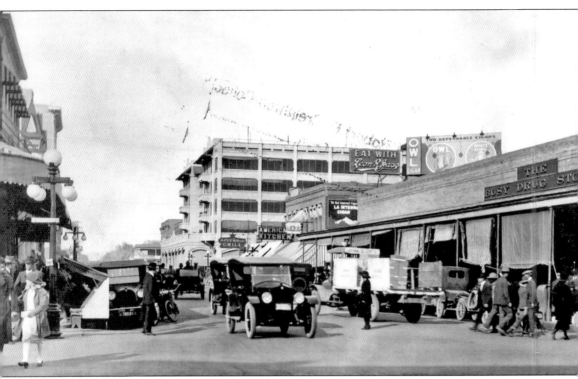

Lawyers cannot live by cool beverages alone. Fuel for waging legal battles could be purchased in the numerous eateries near the courthouse. Shown here, from left to right, are the Splendid Grill, the American Kitchen, and Leon Gass's restaurant on Washington Street. In the early years of statehood, lawyers could eat at the Garden Café, where Sunday dinner was 75¢, or at the versatile French Kitchen, offering its customers "chop suey and noodles at all hours." Phoenix's summertime bachelors of the bar certainly must have frequented the swanky and long-lived American Kitchen restaurant. In the days before air-conditioning, diners were aerated by an arrangement of large, flat fans on the ceiling of the main dining room, attached to each other by a cord that pulled them back and forth. (AHF, CRE-19.)

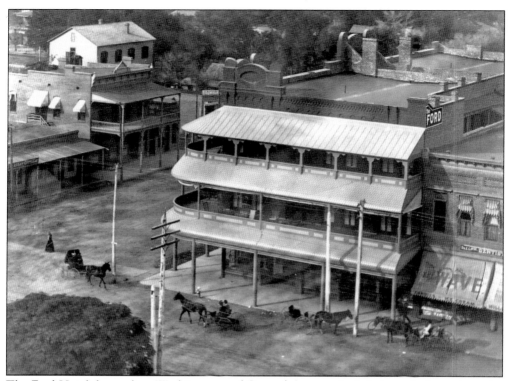

The Ford Hotel, located on Washington and Second Avenue, included a soda fountain and a variety of other amenities. With its spacious sleeping porches, the Ford likely served as a temporary residence for visiting attorneys and judges. (AHF, CRE-86.)

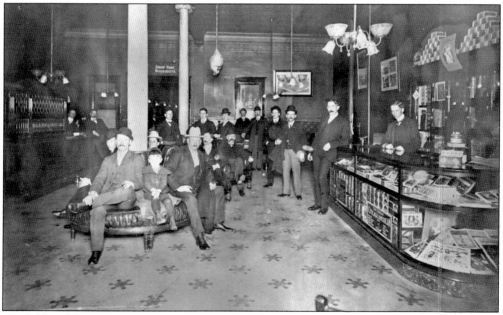

The lobby of the Ford was a busy gathering place for travelers and locals alike. Cigars and tobacco could be purchased and consumed; a 25¢ dinner could be enjoyed in the hotel restaurant; and clients could meet their legal counsel for socializing and strategizing about their case. (AHF, CRE-87.)

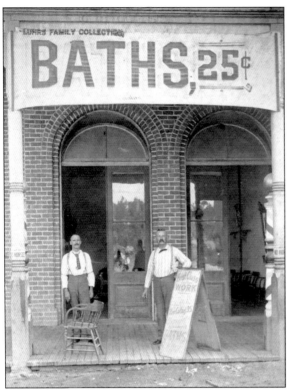

The Commercial Hotel (later the Luhrs) was built at the northeast corner of Central Avenue and Jefferson Street in 1887. An important destination for travelers, it was only a short walk from the courthouse or the local law offices. It promised customers baths for 25¢—always a good idea before heading to court. (Lu, CPLFPC-470.)

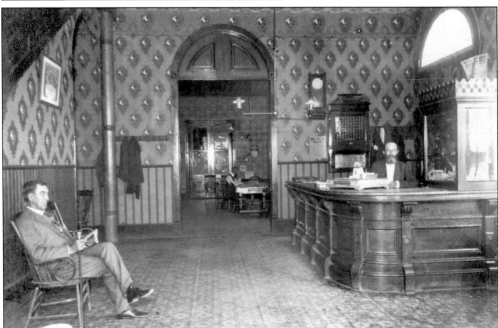

The lobby of the Commercial Hotel, though not fancy, had all the amenities: ready spittoons, gas lamps, a reading room in the back, and through the double doors, a dining room. On the wall by the clock is an electric annunciator—guests in each room could ring once for a bell boy, twice for a waiter, and three or four times for either ice water or hot water. (Lu, CPLFPC-469.)

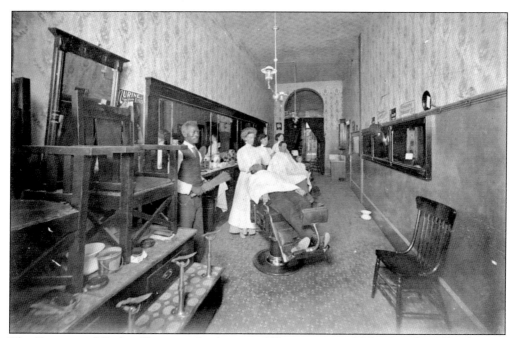

The Commercial Barber Shop was the domain of Phoenix native Helen Hamlin Allen for over 35 years. She no doubt trimmed the locks and shaved the beards of some of the community's legal luminaries. (AHF, HA-1-47.)

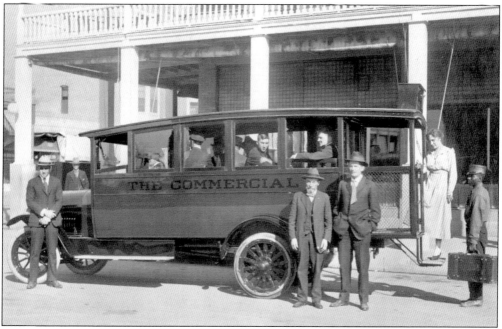

The Commercial Hotel also ran a shuttle service to the train depot. The shuttle greeted all trains and transported passengers and their luggage to the hotel. George Luhrs (second from the left, in front of the bus) was the owner of the Commercial and the patriarch of the Luhrs family, which eventually built the Luhrs Tower and Luhrs Building, still in use in downtown Phoenix. (Lu, CPLFPC-69.)

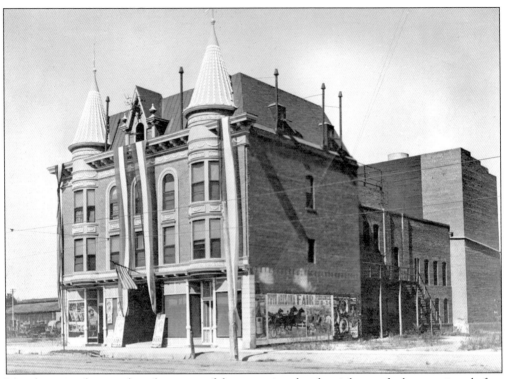

Live theater and movies have been part of the recreational and social scene for lawyers since before statehood. In 1913, performances like the legendary comedic actor William H. Crane as Senator Larkin in *The Senator Keeps House* played at the Elk's Theatre. For the slightly less highbrow litigators, at the Coliseum was Duke "The Posing Athlete, in the Postures of Ancient and Modern Statuary." By the 1930s, elegant downtown movie palaces like the Rialto and Fox were the Friday night hot spots. Pictured are the Elks and the Fox Theatres. (Above, McL, CPMCL-97999.PHX; below, Lu, CPLFPC-1699.)

The weekend before the Maricopa County Bar Association was formed in June 1914, many lawyers spent time in the sun inaugurating the brand-new Riverside Park (the park welcomed 10,000 visitors in its first week of operations). For a 10¢ admission price, the city's new "Playground for the People" offered dancing to an orchestra like Bob Fite and His Western Playboys or Pete Bugarin and His Orchestra on a 40-by-60-foot maple floor under a covered pavilion. First-class meals were prepared by the country club chef, and free feature films were screened every night in an open-air theater. The Riverside would remain one of the city's premiere social venues for the next half-century. This photograph shows an afternoon Riverside tea dance in the early days. (McC, CPMCLMB-A518.)

The pool at Riverside Park was a magnet in the summer. It offered lawyers and their families, amongst other residents, "the finest bathing imaginable" in a 100-by-200-foot space—the largest breakwater swimming tank in the country when it opened in 1914. For decades, it was the city's largest freshwater pool with a huge, 10-meter diving platform and a tall cement slide. (Reed Perkins.)

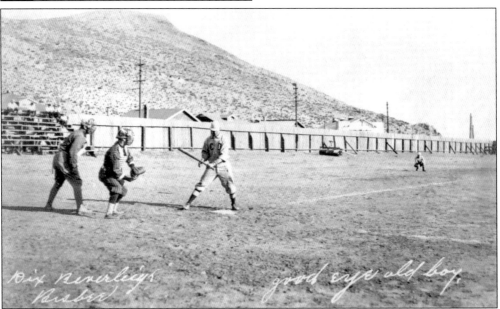

Judges and lawyers have always been baseball fans. In fact, court may have recessed on big game days, when the local baseball heroes, the Senators, were driven around the square before heading to the ballpark. Many would then gather at Riverside Park to watch their team compete in the semiprofessional and loosely organized Desert Baseball League. This photograph depicts a game of the period in Bisbee. (AHF, FPFS-19.)

Then as now, lawyers and their families were both sports fans and amateur participants. The Phoenix Country Club had tennis courts, as did the Tempe Normal School (Arizona State University). Coeducational tennis doubles at the college were both a social and an athletic endeavor. Jackets, ties, and collars were apparently optional for players. (AHF, FPEAS-135.)

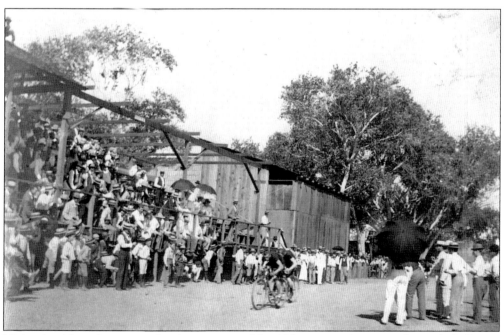

High school bicycle races in the closing years of the 19th century drew a good crowd of all ages. Bicycling was such a popular craze in the late 1800s and early 1900s that racing rivaled baseball as the national pastime. Cycling became a professional sport in 1894, and fans could even exchange cards bearing photographs of their favorite cyclists. (AHF, FPCRE-109.)

Deep in its own end zone, a local football team comes to the line of scrimmage. Like the parents of today, lawyers would make time in their busy schedules to watch their children's high school games. No Friday night fever, though; games had to be played in the daylight for decades, until schools could afford the luxury of lighting their fields. (AHF, FPFS-1.)

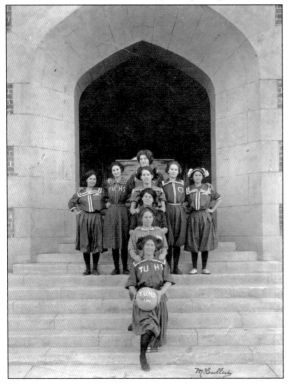

Only 20 years after the invention of the sport by Dr. James Naismith in Massachusetts, the 1911 women's basketball team at Tempe Union High School was a formidable force on the hardwood. Notice the custom uniform detail—likely produced by the player seamstresses themselves. Women had nine players to a side, with three players assigned and restricted to each of three zones on the court. (Tempe Union High School Photographs, Arizona Collection, ASU Libraries, CPSPC-51-3.)

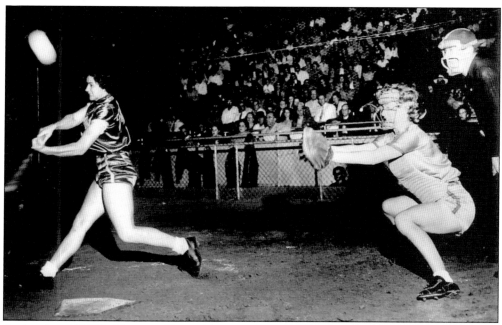

During the mid-1900s, Maricopa County's biggest sport was women's softball. With two championship teams—the Ramblers and the Queens—fan loyalty was sharply split. For a quarter, a lawyer could watch the rivalry at the Phoenix Softball Park at Seventeenth Avenue and Roosevelt. Only a short walk from the supreme court, the games drew huge crowds. The Ramblers brought home Phoenix's first national championship in any sport in 1940. The Queens were touted as "America's Most Beautiful Athletes" and "the Ziegfeld Girls of Softball," and between them, the two teams won eight national titles. Before playing political hardball, former governor Rose Mofford played first base for the Cantaloupe Queens beginning in 1939. These satin-uniformed divas of the diamond put Phoenix on the national sports map. (Above, AHF, Wilk-4; below, AHF, SPC-3.)

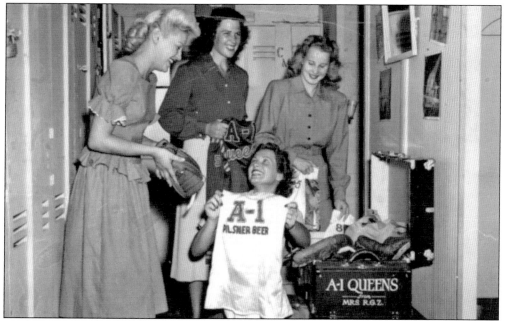

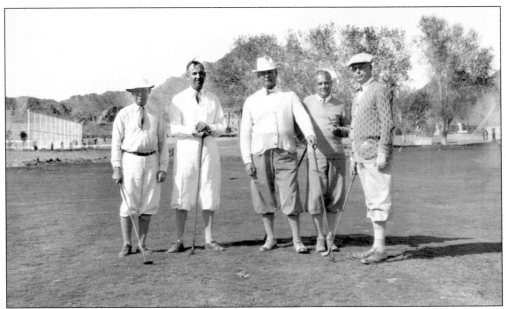

Lawyers, judges, and their professional associates in Maricopa County, just as in other parts of the country, discussed cases and negotiated deals over a few rounds on the links. The Valley of the Sun's many golf courses still provide ample opportunity for year-round deal making. Here some duffers enjoy the Biltmore in the 1930s. (AHF, FPGTS-76.)

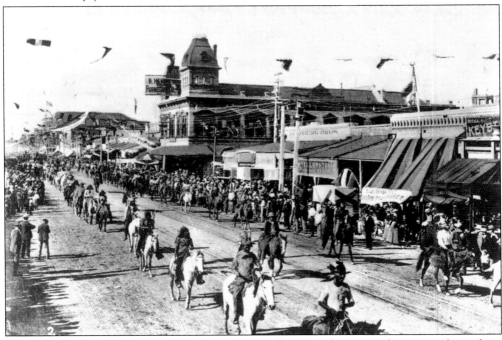

From offices in the Fleming Building, from the courthouse, or from a good spot anywhere along Washington, the legal community could not resist watching a good parade. Most holidays were celebrated with parades, and the Mid-Winter Carnival occurred each year after New Year's Day. This image likely depicts a Winter Carnival parade featuring invited participants from the local Native American tribes. (AHF, FPCRE-60.)

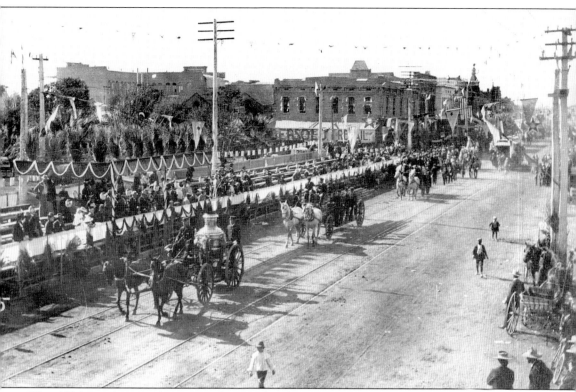

This 1896 parade gave the city's volunteer fire department a chance to show off some of its equipment. The modern Knott steam fire engine, a hook-and-ladder wagon, two hose carts, and 1,000 feet of fire hose had been purchased for $5,000 several years prior. By the time of this photograph, Phoenix had organized Engine Company No. 1, Aztec Hook and Ladder Company No. 1, Pioneer Hose Company No. 1, and a mostly Hispanic group that became known as Yucatec Hose Company No. 2. Just two years earlier, the city had built a large, two-story brick fire station on the northeast corner of Jefferson and First Streets, near city hall. The fire bell hung in the belfry of the city hall building and would toll the number of the ward where the fire was burning. By 1896, a new, 15-box alarm system had been installed to pinpoint the location of the blaze. (AHF, FPCRE-81.)

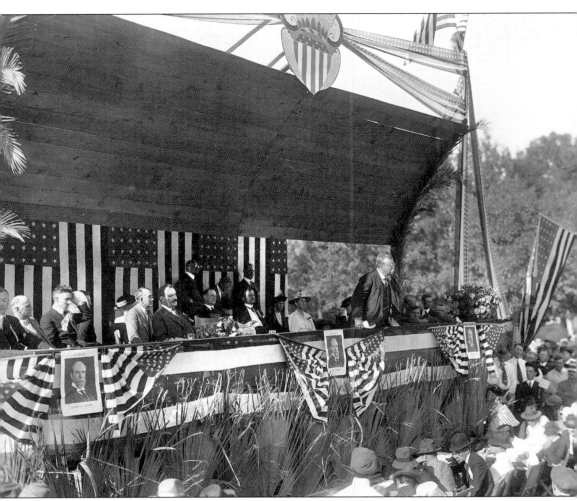

Politics livened up the autumns of even-numbered years and served as diversions for members of the Maricopa County Bar. Here former president Theodore Roosevelt, a popular and frequent visitor to Arizona, speaks to the assembled Republican faithful of Maricopa County on behalf of the candidacy of Charles E. Hughes for president in 1916. Hughes, a fellow New Yorker and governor of that state, had been a member of the U.S. Supreme Court since 1910 but had resigned to run against Woodrow Wilson. Wilson narrowly defeated Hughes, in spite of Roosevelt's support. He was a hard sell in mostly Democratic Arizona. Shortly before his resignation from the court, Hughes had written the landmark decision in *Raich v. Truax*, striking down a popular Arizona anti-immigrant worker initiative. Eventually reappointed to the Supreme Court in 1930, he became well-known again for his outspoken and energetic opposition to Pres. Franklin Roosevelt's efforts to "pack" the court by adding more justices of his choosing. (AHF, FPDD-132.)

The heart of Maricopa County's upper-crust social scene was the Phoenix Country Club. The original clubhouse and nine-hole golf course opened on January 1, 1901, at Seventeenth Avenue and Van Buren Street. It later moved to the end of Central Avenue between Northern and Dunlap Avenues, before settling in its current location. Besides golf, the club allowed for tennis matches, women's teas, dances, and other social events. (AHF, FPCRE-32.)

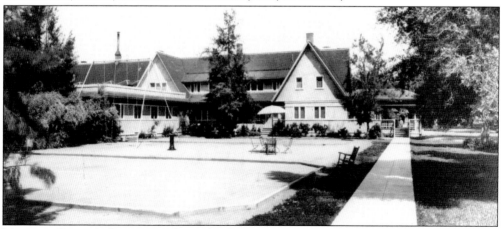

Maricopa County's first resort, the Ingleside Inn, was established in 1910 as a private club for the entertainment of potential investors in the various projects of its builder, W. J. Murphy. The Ingleside was situated eight miles down a country road northeast of downtown Phoenix, surrounded by Murphy's orange groves. In addition to the croquet course shown here, the Ingleside offered an oiled sand golf course and other recreational amenities. (AHF, FPCRE-307.)

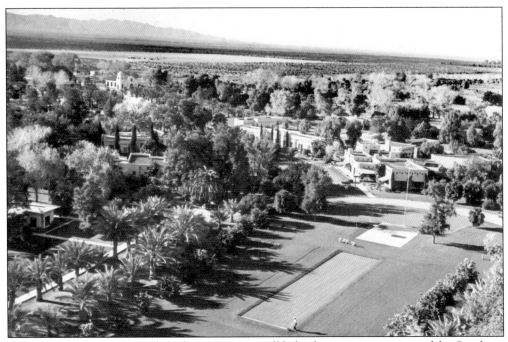

The Wigwam Resort, originally built in 1919 as a small lodge for visiting executives of the Goodyear Tire and Rubber Company, gradually evolved into a dude ranch–style resort in 1929. Local legal luminaries hobnobbed here with the rich and famous, from Bing Crosby and Hopalong Cassidy to wealthy business tycoons. (AHF, FPKR-666.)

Many of Maricopa County's attorneys proudly served in World War II. Arthur Van Haren Jr. enjoyed flying and gained fame as one of Arizona's top naval fighter pilot aces by downing 12 enemy planes. After the war, he graduated from the University of Arizona Law School and settled in Phoenix. He served as deputy county attorney, counsel to the County Planning and Zoning Commission, and a Phoenix city judge. (AHF, FPDD-93.)

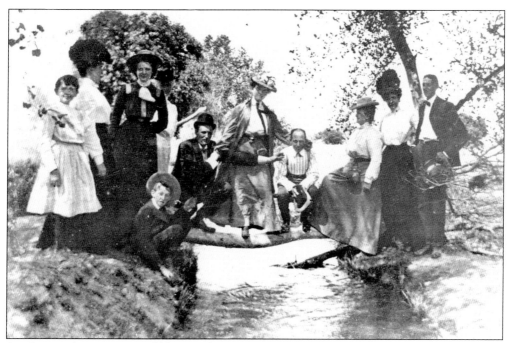

A ride into the country could be an adventure, a romantic excursion, or just a change of pace. The *Arizona Republican* tells of a young attorney and his female companion's long October buggy ride up to Camelback. In the distraction of events related to their picnic, the couple's horse wandered away, leaving "one perfectly good harness, one carriage and one girl, nine miles from civilization." The pragmatic lawyer reluctantly "donned the harness, placed himself between the shafts and started for town." Fortunately for the young barrister, the horse was captured by another party out for similar diversions and returned when the "legally" propelled carriage was sighted. Above, a group of outdoorswomen and their escorts enjoy an afternoon outing to cavort on a precarious canal crossing, while the young group below picnics near Tempe. (Above, AHF, FPCRE-281; below, Lu, CPLFPC-169.)

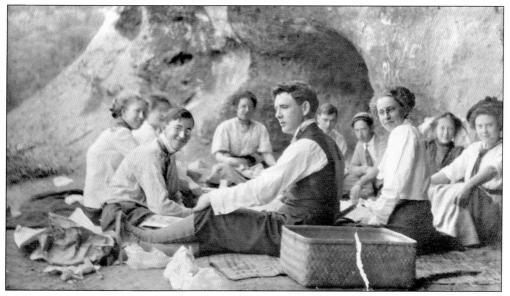

More than a few court sessions were continued due to a judge's affinity for a fine bamboo fishing rod. Judge (later governor) John Phillips, an avid fisherman, could often be found on a Northern Arizona lake. Federal judge David Ling announced at his swearing-in ceremony in 1936 that he had a fishing date the next day that he did not intend to miss. (Lu, CPLFPC-282.)

When a Sunday afternoon drive was not enough or when the valley's summer heat made escape mandatory, a weekend getaway to the mountains was just the thing. County attorney Clyde Gandy found himself limited to just such a short camping trip when Judge Lyman decided in the summer of 1916 to end the practice of closing court in July and August. (McC, CPMCLMB-A960.)

Many wives and families of the area's legal fraternity were part of the annual mass migration to mountain retreats of Northern Arizona or coastal resorts in Long Beach, San Diego, or Santa Barbara. Train fare to the coast was priced at under $25, and fine resort lodging cost $1.50 per day. Beach diversions and coastal breezes entertained these escapees from the Valley of the Sun. Whenever possible, the summertime bachelors left behind would make weekend trips or shorter vacation visits to the cooler locales. What could be more pleasant for a refugee from the Phoenix summer than to join bathing beauties and dapper gentlemen at a cottage on the Santa Monica beach? (Above, Lu, CPLFPC-293; below, Lu, CPLFPC-343B.)

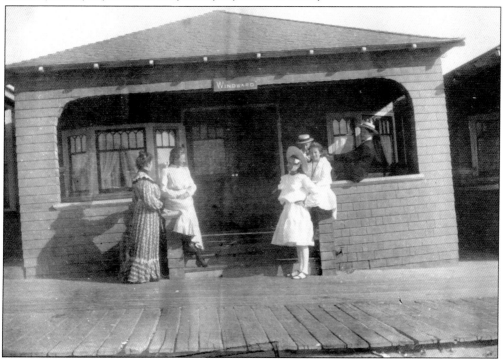

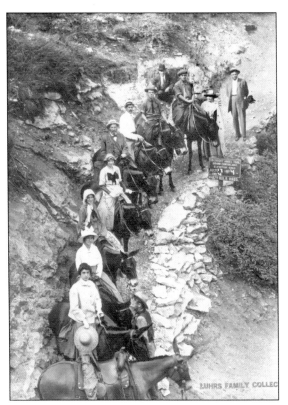

For the more adventurous, nothing was more spectacular than a journey to the bottom of the Grand Canyon. George Luhrs Jr., mounted on the first mule, was a 1920 graduate of the Stanford Law School. He practiced briefly with the firm of Armstrong, Lewis, and Kramer before moving into the family's development business. (Lu, CPLFPC-234B.)

On any given day of worship, Maricopa County's more pious lawyers were to be found communing in the area's churches and temples. Many were leaders in their congregations. Examples include Judge Alsap, who was an ardent Methodist, and Judge Kent, who was prominent in church work at Trinity Cathedral, shown here. (PPL, 3:25 O.)

The Arizona State (or Territorial) Fair was a major attraction, drawing visitors from all over the state, the West Coast, and the Midwest. At various times, the fair featured high-diving horses; Native American and cowboy rodeos; horse, motorcycle, and automobile racing; and, of course, musical performers of all sorts. Fair shuttles ran regularly from downtown Phoenix. (AHF, FPCRE-264.)

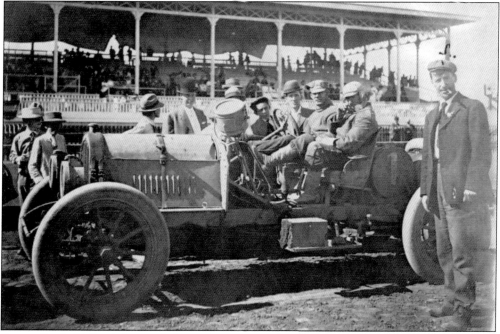

George Purdy Bullard, Arizona's first attorney general and an automobile racing enthusiast, was responsible in 1914 for two cross-country races that would both conclude at the state fair. The drivers included big names in racing such as Barney Oldfield, considered the fastest man on wheels. This car appears to be just finishing one of those grueling races. (AHF, FPCRE-225.)

Last-minute holiday shoppers of the early 1920s had many different options of how to spend their hard-earned legal fees. Advertisers like Goldwater's and the Boston Store encouraged people to purchase neckties (9 out of 10 American men would receive one for a holiday gift) for between 25¢ and $2, handkerchiefs for either 5¢ or 10¢, silk sweaters for $16.50, and fountain pens for $2.50. Community celebrations in Phoenix centered around the 30-foot Christmas tree set up in the lobby of the Hotel Adams and the Municipal Christmas Tree in the city hall plaza. The *Arizona Republican* reported that on the afternoon of Christmas Day, "the tower, the deep toned bells, the brilliantly lighted tree, the Christmas greens transforming a busy city street, the happy crowd, spoke straight to the heart of every person present, whether 7 or 70." Poor children were given the opportunity to attend the theater for free matinee runs of the moving pictures. (Lu, CPLFPC-145.)

Maricopa County's lawyers usually earned a comfortable living—some were affluent, while some became quite wealthy, usually by supplementing their legal fees with real estate or other investments. Lawyer Pearl Hayes and his wife, Susan, lived in the above well-landscaped home at 1016 North Second Street. Just north of Roosevelt Street, the tidy neighborhood seems to have had well-manicured lawns and no visible fences in 1912. In 1898, attorney Frank Cox lived in the fine two-story home at 802 West Washington, pictured below. Pioneer woman lawyer Alice Birdsall originally made her home in the Adams Hotel, but after nearly 20 years there, she moved to the San Carlos Hotel in 1933. (Above, AHF, FPPF-21; below, AHF, FPCRE-258.)

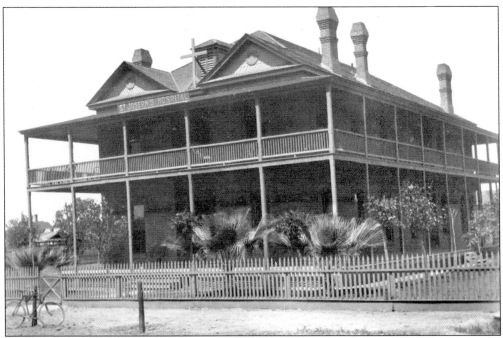

St. Joseph's Hospital, at the northeast corner of Fourth Street and Polk, was constructed in the 1890s; destroyed by fire, it was rebuilt in 1917. The 24-room facility was expanded over the years and served the community until the mid-1940s. When a new St. Joseph's was to be built "out in the country" at Third Avenue and Thomas, wandering dairy cows had to be shooed away during the ground breaking. (AHF, FPMC-H-286.)

The lawyers of early Maricopa County had more than their share of interactions with the unfortunately named local undertaker. Life was dangerous and often short in the Arizona Territory, and George Merryman's profession was a lucrative one. (AHF, FPCRE-125.)

Six

GETTING THERE IS HALF THE FUN

Arizona's early judges and other court officials were required to "ride the circuit" from courthouse to courthouse. Territorial attorney general Coles Bashford recounted the perils of his lonely travels from Tucson to La Paz to Prescott, and back to Tucson. He traveled on horseback by night to avoid attacks by hostile Native Americans and bandits, wandered through canyons without marked trails, and swam rivers where there were no bridges. Later district court judges like Judge DeForest Porter made their way to Phoenix for the spring and fall sessions by the slightly less dangerous means of Concord stagecoaches pulled by four- and six-horse teams.

On the afternoon of June 1, 1914, when the Maricopa County Bar Association was founded, Phoenix was already a motoring city. It boasted 29 miles of paved roads, including Central Avenue, which was paved for nine miles. Gasoline was 18¢ per gallon. The lawyers of the city certainly owned their share of the 2,200 operational automobiles (almost 1 for every 10 residents) that cruised Washington Street and First Avenue around the Old Courthouse. From their Stutz Roadsters, Hupmobiles, Fords, and Studebakers, legal luminaries could admire the lushly landscaped green space surrounding the 1889 two-story brick courthouse and its clock tower as they commuted to offices in the Fleming Building, on the northwest corner of Central Avenue and Washington Street, and other seats of commerce. Since those early days of statehood, the lawyers of Maricopa County, as well as other residents, have never stopped driving.

Despite the ubiquitous use of automobiles, Maricopa lawyers and judges have made their way to the courthouse by a variety of means. From ox-drawn wagons, to bicycles, to trolleys, to the railroad and airplanes, attorneys have used whatever conveyances were available to them to serve the needs of their clients efficiently.

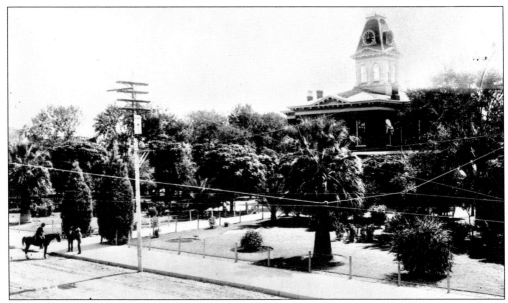

For the first 30 years of county history, those with business at court arrived by foot, on horseback, or by wagon (in later years, bicycles were another option). As this photograph shows, parking problems were not an early concern at the courthouse. (McL, CPMCL-34573.)

In the years before the railroad, ox and mule teams provided the locomotion for freight and some passengers that made their way to the communities of the Salt River Valley. The legal paraphernalia needed to serve the clients of Maricopa County, including law books, desks, paper, and ink, as well as clients and a few lawyers themselves, was delivered across the desert by these hard-working transporters. (AHF, FPX-10.)

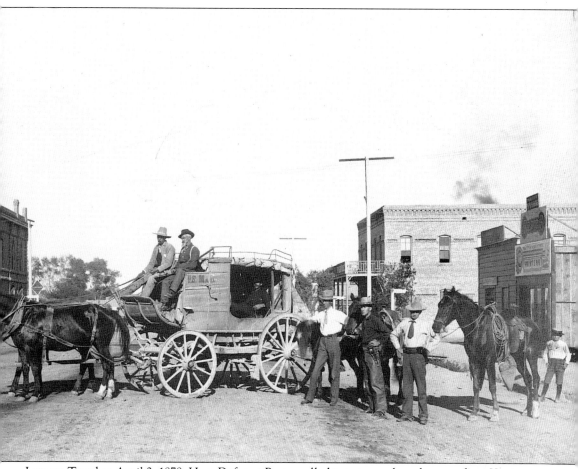

Late on Tuesday, April 2, 1878, Hon. Deforest Porter rolled into town aboard a stage from Yuma, similar to the one shown here. The court session, mandated by the territorial legislature to begin on the first Monday in April, was delayed because the judge could not get a seat on an overcrowded earlier coach. Judge Porter had spent at least 20 continuous hours cooped up in the "cozy" confines of the stage, crowded with other dusty, tired, jostled, and perhaps short-tempered travelers, their luggage, and the U.S. Mail. The coach stopped every 10 to 15 miles for fresh horses, and passengers were fed quick meals of dried beef, bread, and on a lucky occasion, beans. There was no overnight stop and no opportunity for washing or otherwise "freshening up." First-class passengers did not have to disembark during difficult stretches, but second-class fares had to walk on steep inclines, and third-class ones even had to help push the coach in times of need. Depending on the weather, passengers shared blankets to keep warm or communally roasted, with only flow-through ventilation to cool the crowded quarters. (AHF, Goldwater Historic Photographs.)

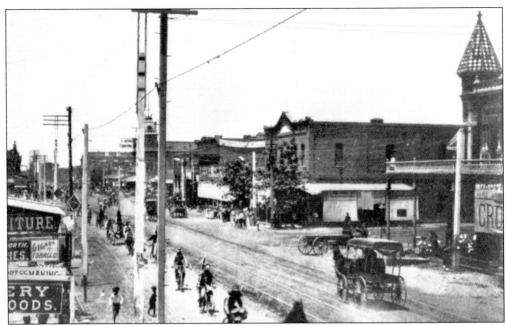

In later territorial times, lawyers headed to court or their offices faced a little more traffic congestion but were also offered the convenience of the citywide trolley system. Those with business in the supreme court or the state boards/commissions paid a nickel for the short, 5- to 10-minute trolley ride from their offices at the Fleming Building to the capitol. The Phoenix Railway Company's bright yellow cars could be caught going east or west on Washington Street every 15 minutes from 6:00 in the morning until 10:45 p.m. The clanging of the trolley bell as the car passed each intersection provided a persistent soundtrack to the legal comings and goings around the courthouse. (Above, AHF, FPCRE-69; below, AHF, FPCRE-14.)

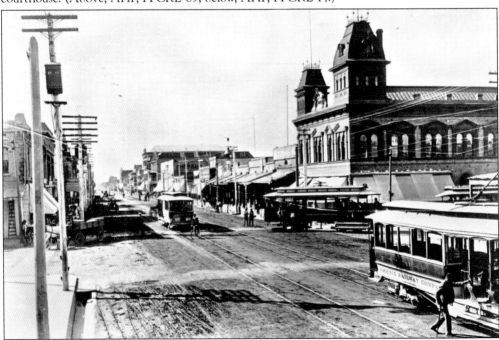

When local barristers had a case in Gila County, they likely took the Apache Trail Stage Company, departing from downtown Phoenix and proceeding east through Tempe and Mesa, on via the Apache Trail to Roosevelt Dam, then southeast to Globe-Miami. Cars traveled each way daily. The tiring trek took passengers over dusty, jarring, and "scenic" dirt roads, without air-conditioning or heat. Assuming no washouts, rock slides, or breakdowns, the one-way trip took about eight hours and cost $15. The weary road warriors could, in the best-case scenario, be back in their own beds after only a night or two away. Just such a trip is blamed for the untimely death from pneumonia of one of Arizona's pioneer woman lawyers, Sarah Sorin. Sorin traveled from Globe to a tax commission hearing in April 1914 and died a few days later. (McC, CP MCLMB-A961.)

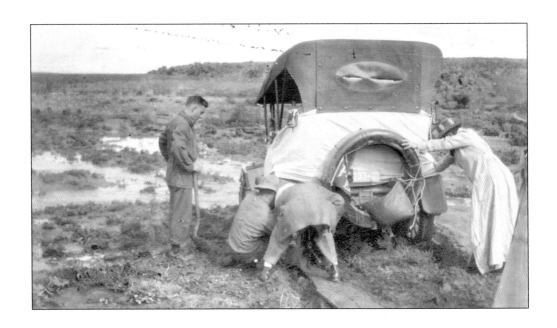

Roads were not always located where lawyers needed to travel, and sometimes the roads that were there would disappear after a good desert storm. For example, the rains of December 1914 created as wet a holiday season as anyone could remember. The washes all flooded. The streets of Phoenix were a deep, muddy mess. During the week between Christmas and New Year's, only one car, a Buick, made the sloppy road trip from San Diego to Phoenix. What was normally an easy one- or two-day trip took these adventurous motorists a grueling five days. (Above, Lu, CPLFPC-230; below, AHF, FPCRE-224.)

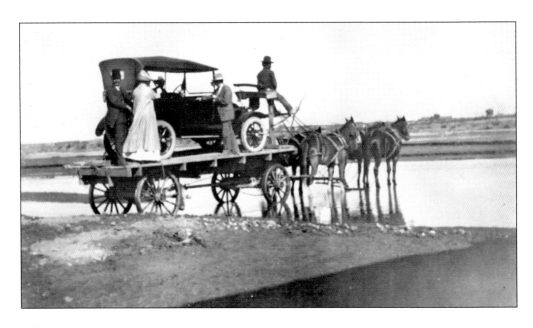

Even if the roads cooperated, the hazards of desert driving required special planning. The driver of this well-provisioned touring car, likely headed on a short camping trip, was prepared for the effect of the desert heat on his engine. Apparently refreshing a hot engine was a fairly routine procedure, and in this case the passengers did not even bother to disembark. (AHF, FPCRE-295.)

By the early 1920s, parking at the courthouse was officially a problem. The first meters were not invented until 1936, and it was some time after that before large parking lots or parking structures became available. Clearly, the art of parallel parking was in full bloom by the time of this photograph. (McC, CPMCLMB-A508A.)

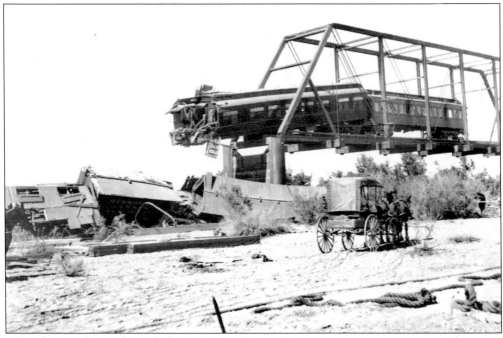

Often the courthouse that called prominent Maricopa County attorneys was not across the street, but rather in Pasadena, San Francisco, or even Washington, D.C. The logistics of attending hearings and meetings in these far-flung forums during the first few decades of the 20th century usually involved rail travel. Barring uncertainties like the collapse of the Maricopa and Phoenix Railroad bridge at Tempe in 1902 (above), this type of transportation was relatively comfortable and reliable. In 1913, a lawyer could board the Arizona Eastern train at 6:15 a.m. and, with luck, reach Los Angeles by 7:30 p.m. the same day. Overnight trains were also available. Connections to points east over both lines usually routed through Kansas City and Chicago. The trip to Chicago by either route entailed at least three days, with another day or two to get to the Supreme Court in Washington. (Above, AHF, FPMCH-273.1; below, AHF, CRE-160.)

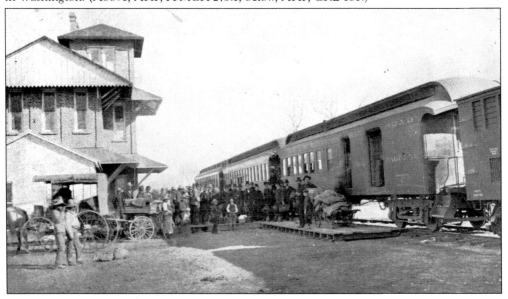

Getting to and from the office or the courthouse downtown has not changed much since the 1950s (below) or even the 1920s (above). Commuter lawyers, judges, and their staffs may have a longer drive now than in years past, but the skills necessary to negotiate congested traffic, careless pedestrians, and difficult parking have remained fairly constant. The changing streetscape has done little to make the harried lawyer's commute any easier. (Above, AHF, FPCRE-41; below, AHF, FPCRE-84.)

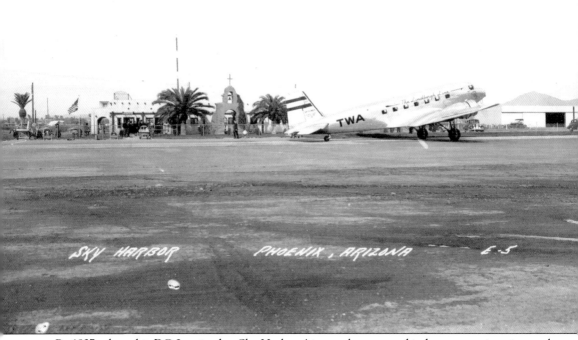

By 1937, when this DC-2 arrived at Sky Harbor Airport, lawyers and judges were using air travel to reach the more remote courthouses of Arizona, the East and West Coasts, and points between. As early as the fall of 1929, federal judge Jeremiah Netterer flew into the new airport to fill in for Phoenix's own Judge F. C. Jacobs, who had been called to California during the October session of the court. At that time, Sky Harbor boasted the only regularly scheduled interstate flights to and from Phoenix and was located only three miles from the judge's courtroom. The mission-style chapel, visible behind the TWA flight, was built in 1937 and used by those interested in "fly-in" marriages. Lucky brides and grooms could fly into the airport, purchase a marriage license, have a ceremony in the chapel, and ride the next flight out of town in wedded bliss. (AHF, FPCRE-214.)

Seven

FREEDOM OF ASSOCIATION

Lawyers have always joined with their peers for commercial and professional growth. Law partnerships naturally developed and dissolved as the local bar grew in numbers and the community's need for legal services evolved. Similarly, formal and informal bar associations were established for attorneys practicing in a geographic area or those who shared common interests or demographics. Maricopa County's lawyers and judges were no exception.

New lawyers would frequently associate themselves with more established attorneys to gain experience and then move on to their own practices. Alice Birdsall, one of Maricopa County's first female attorneys, spent a few years in a Globe partnership with Arizona's first female lawyer, Sara Sorin, before moving to Phoenix to open her own solo firm. Similarly, when early Hispanic attorney Greg Garcia started practicing in Phoenix, he joined Anselm Y. Moore in the Fleming Building; he later set up his own law office.

Prior to 1933, when Arizona's legislature finally approved creation of a mandatory state bar association closely tied to the supreme court, Maricopa County's lawyers participated in local or statewide voluntary bar associations primarily for the fellowship and food. Occasionally, these associations would mobilize for the political benefit of a member, but the social aspects of the organizations seem to have been most important. For example, the menu from an 18-course, 3-wine banquet held at the Opera House Café in Phoenix in 1895 survives, but meeting minutes and even the names of state bar officers cannot be located for much of the first 10 years after statehood.

Whether in their law school classes, various bar associations, or historic firms, the attorneys and judges of Maricopa County have frequently come together for professional, business, and social purposes.

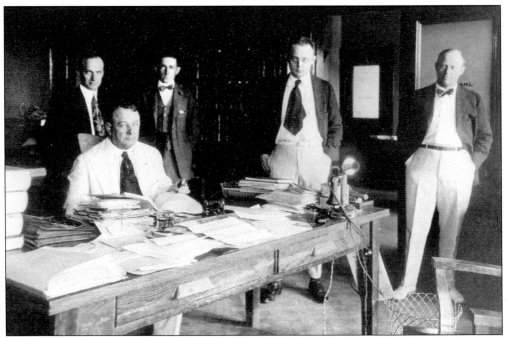

The Fennemore Craig law firm traces its history back to 1885, to the partnership of Louis Chalmers and Richard E. Sloan. Chalmers practiced until his death in 1934. His partners and their successors have continued to operate the firm without interruption to the present. Harry Fennemore and Jubal Early Craig joined the firm in 1912 and 1927, respectively. In this 1921 photograph, Chalmers sits in his office, and Fennemore stands to the far right. (Fennemore Craig, P.C.)

In 1942, the partnership of Jennings, Strouss, Salmon, and Trask opened on the sixth floor of the Phoenix Title and Trust Building at First Street and Adams. The firm's founders were Irving A. Jennings Sr., Charles L. Strouss Sr., Riney B. Salmon Sr., and Ozell M. Trask (pictured). (McL, PORT Trask, OzellM.-4.)

Snell and Wilmer was founded in Phoenix in 1934 as Snell, Strouss, and Salmon. Frank Snell Jr. had practiced earlier as a solo attorney in Miami, Arizona. Mark Wilmer joined the firm in 1938. Here Snell helps on a demolition project allowing for the new growth that he and his firm epitomized. (AHF, FPPC-11:10.)

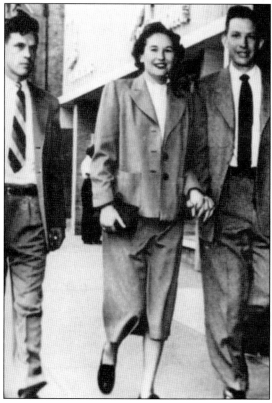

Francis J. Ryley opened his own firm in Phoenix on January 1, 1948, and was joined three weeks later by new law school graduate Read Carlock. In 1952, the partnership of Ryley, Carlock, and Ralston was formed, and in 1984, the firm was renamed Ryley, Carlock, and Applewhite. Joseph Ralston (left) and Wanda (center) and Read Carlock stand on Washington Street in 1950. (Ryley, Carlock, and Applewhite.)

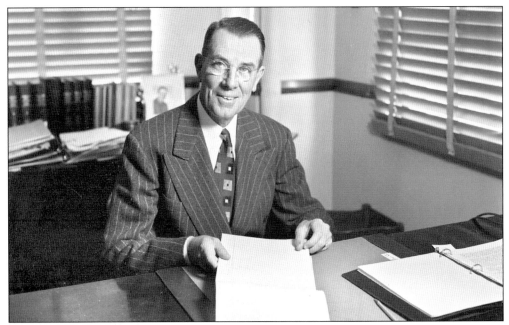

The firm know as Carson Messinger was founded in 1924 by Gene S. Cunningham (shown) and Charles A. Carson Jr. Cunningham, a University of Illinois Law School alumnus, was admitted to practice in Arizona in 1913, one year after statehood, and served as Maricopa County attorney prior to founding the firm. Carson was admitted to practice in Arizona in 1922 after studying and "reading the law." (McL, PORT Cunningham, GeneS-1.)

A group of at least 50 lawyers established the Maricopa County Bar Association (MCBA) on the evening of June 1, 1914, meeting in Judge John Phillips's courtroom. Over the years, the MCBA grew and acquired its own staff and offices. This Roosevelt Street building housed the bar prior to the purchase of its current offices. (MCBA.)

In June 1971, Joshua Bursh (the fourth African American admitted to the Arizona Bar), Charles Murrey, and Cecil Patterson (the sixth admittee, shown here when he served as a judge of Division I, Arizona Court of Appeals) formed the Arizona Black Lawyers Association and met most Friday afternoons to discuss their practices. They were soon joined by established attorney Carl Stewart and others. The association was renamed in the 1980s to honor Judge Hayzel B. Daniels. (Arizona Black Bar and Judge Cecil Patterson.)

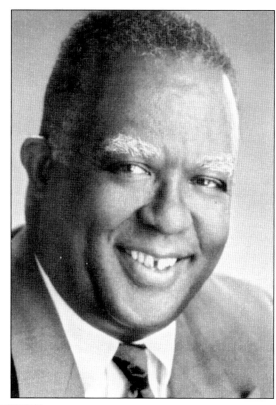

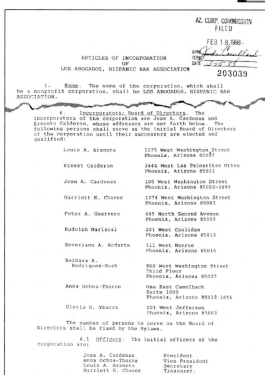

In the late 1970s, Maricopa County's Hispanic lawyers began meeting in offices and restaurants to discuss ways they could work together to improve representation of Hispanic clients. These informal get-togethers evolved into Los Abogados, the Maricopa County Hispanic Bar Association. Eventually, in 1988, the organization was incorporated. Corporation documents list many of the community's leading attorneys and judges as early members. (Los Abogados.)

125

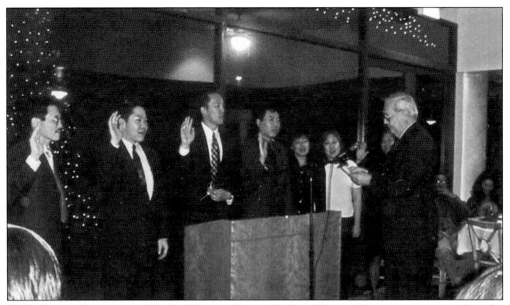

With the encouragement of Judge Thomas Tang, the first Chinese American appointed to the federal bench, the Arizona Asian American Bar Association was formed in Phoenix in 1993. Marian Yim served as the association's first president. During this 2000 swearing-in ceremony, Justice Paul Jones administered oaths to, from left to right, Judge Paul Tang, Barry Wong, George Chen, Bernard Wu, Judge Rosa Mroz, Catherine Parker-Williams, and Lisa Loo. (Arizona Asian American Bar Association.)

The Arizona Women Lawyers Association (AWLA) was organized in the spring of 1977. Early members, such as the first president, Lucia Fakonas Howard, met monthly for lunch. This photograph shows a reunion of founding members of the AWLA on the organization's 30th anniversary. (AWLA.)

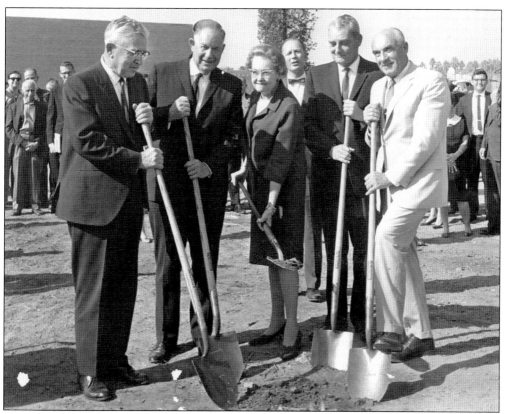

The Arizona State University School of Law was established in 1967 and was renamed the Sandra Day O'Connor College of Law in 2006. Celebrating the school's ground breaking are, from left to right, Arizona Supreme Court justices Jesse Udall, Ernest W. McFarland, Lorna E. Lockwood, Fred J. Struckmeyer Jr., and Charles C. Bernstein. Founding dean Willard Pedrick appears in the background. (Sandra Day O'Connor College of Law at Arizona State University.)

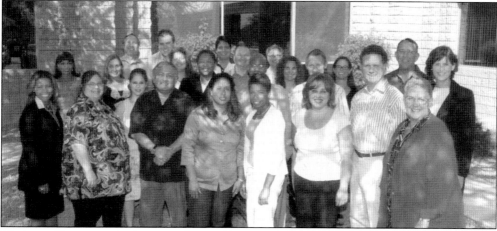

Maricopa County is also home to the state's newest law school, the Phoenix School of Law. It opened in early 2005 in a Scottsdale Airpark building with 25 students. By 2007, enrollment had grown to over 150 and the school had relocated to Central Avenue in Phoenix. Shown are the original building, faculty, and staff. (Phoenix School of Law.)

Across America, People are Discovering Something Wonderful. Their Heritage.

Arcadia Publishing is the leading local history publisher in the United States. With more than 4,000 titles in print and hundreds of new titles released every year, Arcadia has extensive specialized experience chronicling the history of communities and celebrating America's hidden stories, bringing to life the people, places, and events from the past. To discover the history of other communities across the nation, please visit:

www.arcadiapublishing.com

Customized search tools allow you to find regional history books about the town where you grew up, the cities where your friends and family live, the town where your parents met, or even that retirement spot you've been dreaming about.